Published in 2023 by Welbeck
An imprint of Welbeck Non-Fiction Limited,
part of Welbeck Publishing Group.
Offices in: London - 20 Mortimer Street, London W1T 3JW &
Sydney - Level 17, 207 Kent St, Sydney NSW 2000 Australia
www.welbeckpublishing.com

A CIP catalogue for this book is available from the British
Library.

ISBN 978-1-80279-616-2

Printed in China

10 9 8 7 6 5 4 3 2 1

ICONS OF STYLE

Diana

ICONS OF STYLE
Diana

The story of a fashion legend

Glenys Johnson

WELBECK

CHAPTER 3

The Key Pieces

140

CHAPTER 4

Her Legacy

186

"I like to be a free spirit.

Some don't like that, but that's the way I am."

PRINCESS DIANA

Introduction

Burned into the memories of many of those who were glued to their TV sets to witness the event, the speech given by Diana Spencer's younger brother at her funeral on 6 September 1997 gave us a line that summed up her character perfectly. "Diana was the very essence of compassion, of duty, of style, of beauty. All over the world she was a symbol of selfless humanity."

Though she was in many ways a divisive figure in her lifetime, Diana, Princess of Wales, remains an icon. The word befits her charm, her philanthropic work, her playful approach to motherhood – and her fashion sense.

But what makes somebody an icon? It's a word thrown around too freely in this age of social media exaggeration. To be iconic is to be idolized in life – and in death. It's to be known by your first name alone. It's to be not merely representative of one era but to live on as an eternal memory, remaining relevant in future decades. Many of Diana's biggest fans didn't witness the frenzy she created while she was alive, but they'll continue to find new reasons to fall in love with her and refresh her legacy in new ways.

Diana attends an event in Italy sporting crystal heart earrings by Butler & Wilson and a silk suit by Bruce Oldfield, 1985.

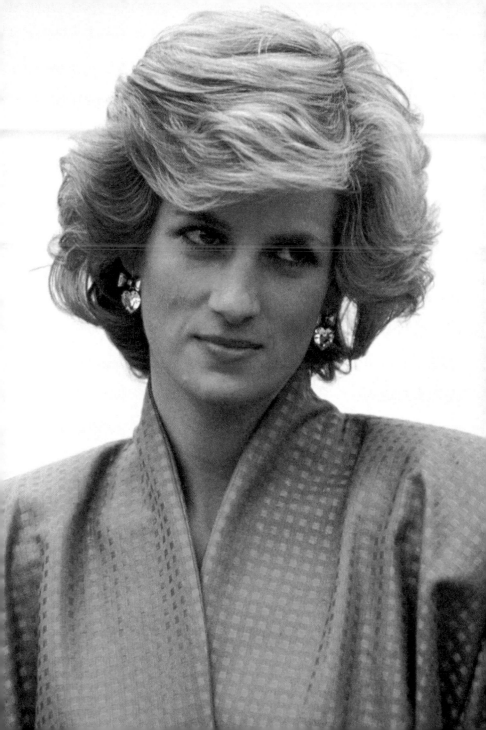

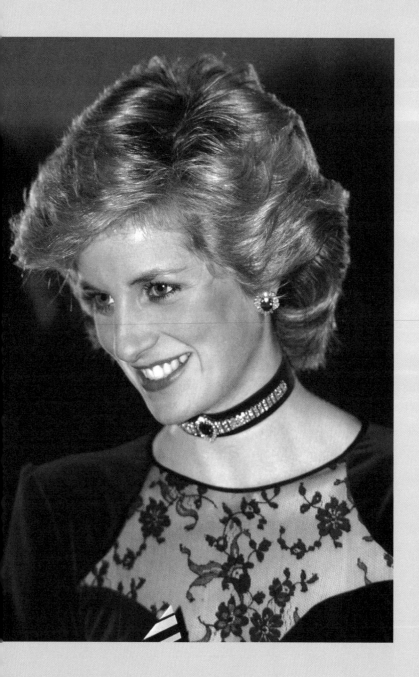

"Only do what your heart tells you."

Diana's outfits have come to represent far more than she could ever have imagined. Even media commentators of the eighties and nineties, who were obsessed with her, could not have predicted her current rebirth across social media. Millennials, just old enough to remember her, and Gen Zers, many born after her death, bring a whole new level of analysis and imitation to her most famous looks.

Diana's story is the haunting tale of a princess who came to a tragic end. The public will never have all the answers, but for each new generation there's an allure in shaping our own interpretation of her story. Once the most photographed woman alive, she leaves behind a documentary legacy unmatched by anyone before her. At the touch of a button or the turn of a page, it's ours to analyze: the messages contained in her fashion choices and the magic of the threads that were woven to create a wardrobe unlike any other.

Diana wears one of her trademark pieces of jewellery, an emerald choker, to the Newport International Competition for Young Pianists in 1985.

Style

Trajectory

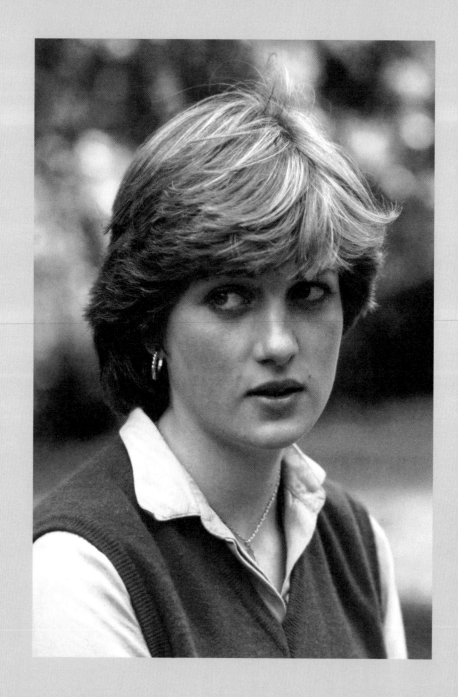

The evolution of a wardrobe

Born Diana Spencer on 1 July 1961 to parents John Spencer and Frances Shand Kydd, Lady Diana would go on to become one of the most famous faces of the twentieth century. Her rise to fame began with her marriage to Charles III, then the Prince of Wales, but many would forever remember her for her charm and her unshakable kindness. And alongside her philanthropy and her dedication to making the world a better place, her wardrobe would always shine bright.

From the frill collars of the eighties to the mini dresses of the nineties, Diana's inspirational life of independence and charitable deeds was accompanied by outfits that always told a story. Now, decades later, her legacy lives on through the modern-day It girls, pop stars and leading actresses who continue to reference Diana's daring looks both on and off the red carpet.

What did it take for this somewhat shy, affectionate child to become the most famous woman in the world? Many pages and many words have gone into tracing this lineage, drawing a thousand conclusions. But what if the clothes signalled more than anyone who was watching thought? Observe Diana's evolution from preppy Sloane Ranger to world-famous femme fatale and draw your own conclusions.

A teenage Diana is captured by photographer Arthur Edwards on a break from her duties at a nursery in Pimlico, 1980.

Sloane Ranger

The early eighties was an unforgettable time for fashion. In New York there were the hip-hop crews in their baggy clothes and sportswear ensembles. London was inhabited by an eclectic mix of leather-clad punks, New Romantics (defined by their stark make-up, larger-than-life hair and Gothic style) and, most importantly (for this book, anyway), Sloane Rangers.

A unique, British approach to what many Americans would define as the "preppy" look, the Sloane Ranger style was embodied and defined by the upper-middle-class youth who lived near Sloane Square, in the London district of Kensington. Amid a sea of Barbour jackets, corduroy trousers and flowing pleated skirts, we meet the shy 19-year-old Diana Spencer. Diana was to bring the Sloane Ranger style to the international stage – but at the time, her look was very much a drop in the bucket, simply the uniform that everyone wore. It signalled that she belonged to a particular class. The Sloane wardrobe was said to have been influenced by a traditionally minded lifestyle which took in weekends at the family home in the country and weekday glasses of red at one of the higher-end drinking holes in the area. The Fulham pub The White Horse, known to locals as the Sloaney Pony, was full of Sloane Ranger types throughout the early eighties.

Diana's role in bringing Sloane Ranger style to the masses is highlighted by her cover spot on *The Official Sloane Ranger Handbook*, released in 1982, two years after the release of *The Official Preppy Handbook*, which defined the Sloane's

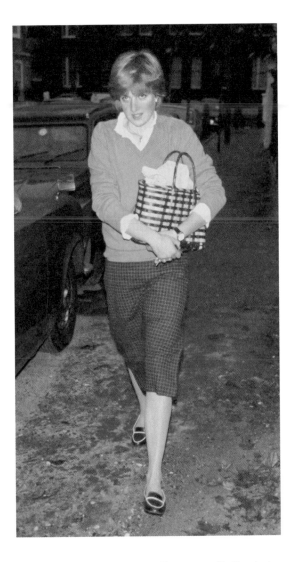

ABOVE A young Diana is captured by paparazzi in Kensington amid rumours that she is dating Prince Charles, 1980.

OVERLEAF Posing a contrast to the Sloane Rangers were the New Romantics, pictured here on Chelsea's King's Road, 1980.

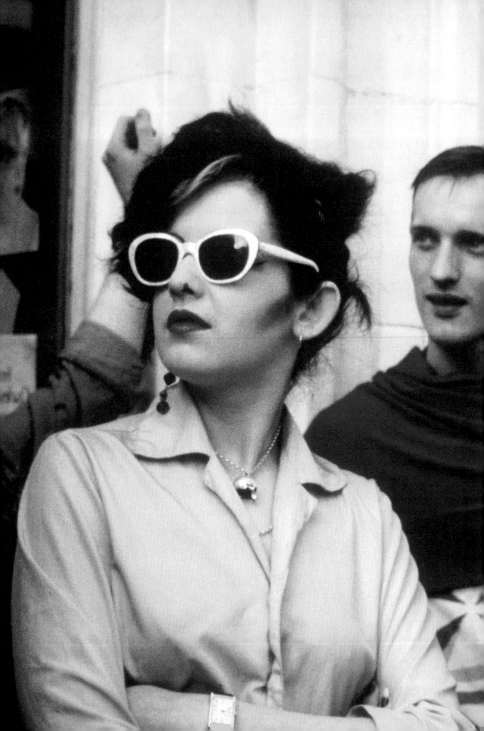

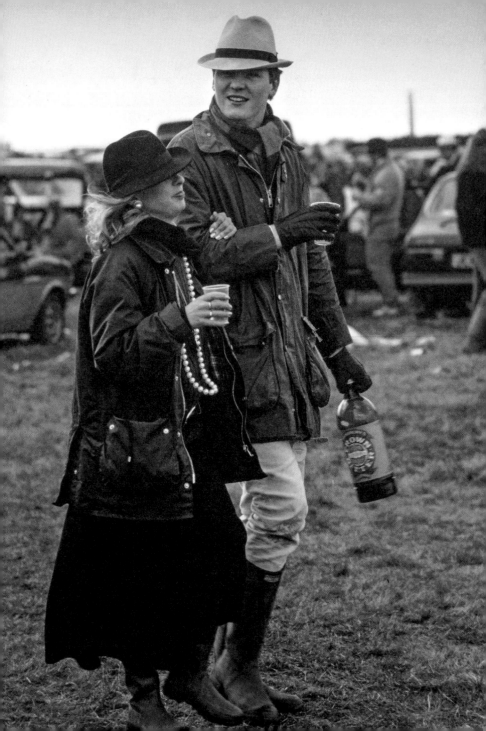

"When Diana Spencer began to appear in newspapers in the summer of 1980, the Sloane Ranger style began its gallop down to the high streets."

THE OFFICIAL SLOANE RANGER HANDBOOK

A typical Sloane couple, here attending a horse race in Liverpool, 1985.

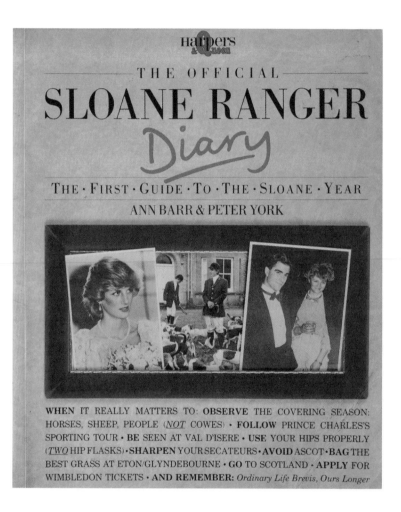

The Official Sloane Ranger Handbook inspired books like *The Official Sloane Ranger Diary*, with Diana appearing on the cover.

American counterpart. Both books took a satirical look at the style-focused communities and their seemingly endless list of insider rules – from the forms of transport that were acceptable (Diana drove a modest Volvo when she started dating Charles, a vehicle embraced by the Sloanes as robust and practical) to the alcoholic drink choices that were celebrated. The handbook was followed up with *The Official Sloane Ranger Diary* in 1983, Diana again gracing the cover.

Peter York, co-author of *The Official Sloane Ranger Handbook*, explains the phenomenon best. In a 2001 article for the *Guardian*, he stated, "The Sloane was a whole social phenomenon in the mid-eighties, really about upper-middle-class social conventions and styles. It was not a life of the mind, but you knew where you were."

Feminine floral dresses from Laura Ashley, timeless waxed-cotton jackets from Barbour and tweed styles from Bill Pashley filled the wardrobes of the twenty-somethings, which also contained small hints of luxury from brands like Burberry and Chanel. Dressing "sensibly" was a key element of the Sloane Ranger aesthetic. Though the influence of modern fashion was evident, the core of their uniform would never steer too far from traditional, old-money styles. Oversized cotton jumpers would be paired with a pleated floral midi skirt and Chanel flats. Knitwear was handed down from mother.

Some of the earliest photographs of Diana, from the early 1980s, demonstrate the young aristocrat's firm stance as a true Sloane Ranger, sporting knitwear paired with breezy skirts and simple flats. Details were key to finishing off the look: pearls and simple gold-tone jewellery added an angelic touch. A feathered shag haircut and minimal make-up

followed Diana through the earlier part of the decade. She didn't reach for a curling iron or lipstick until she began to receive invites to high-profile events.

One of the first public images captured of Diana made the headlines and had people across the globe analyzing her fashion choices: a trend that would continue throughout her life. Diana was just 19 years old when royal photographer Arthur Edwards paid her a visit at her workplace, Young England Kindergarten in London's Pimlico. The story goes that Diana's white skirt displayed a silhouette of her legs because of the angle of the sun.

"Everybody doesn't believe this, but it is the gospel truth – halfway through, the sun came out," Edwards told *Today.com* in 2017, denying that the shots were planned on purpose or intended to embarrass the young kindergarten assistant. Diana felt the impact of the press attention and according to rumours, told Charles that she "didn't want to be known as the girlfriend who had no petticoat". It's safe to say that the photo shoot was quickly overshadowed by Diana's other headline-making moments.

The wholesome, soft-spoken and down-to-earth Diana was the perfect poster child for the Sloane Ranger look and lifestyle. But Diana's simple life would be rapidly turned upside down as her relationship with Charles developed and she went from Diana Spencer, the Sloaney kindergarten worker, to the Princess of Wales, role model to young women across the world, philanthropist and mother of two. With her new title came a style evolution witnessed by fans who couldn't wait to see what looks she'd wear next.

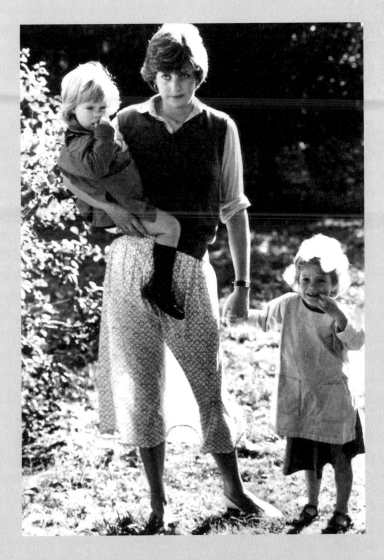

ABOVE Diana tends to two children who attended the nursery where she worked. This shot would be the first of countless images to secure her a headline spot in the papers.

OVERLEAF Wearing the Sloane Ranger uniform with pride, Diana is captured by photographers outside her flat in November 1980.

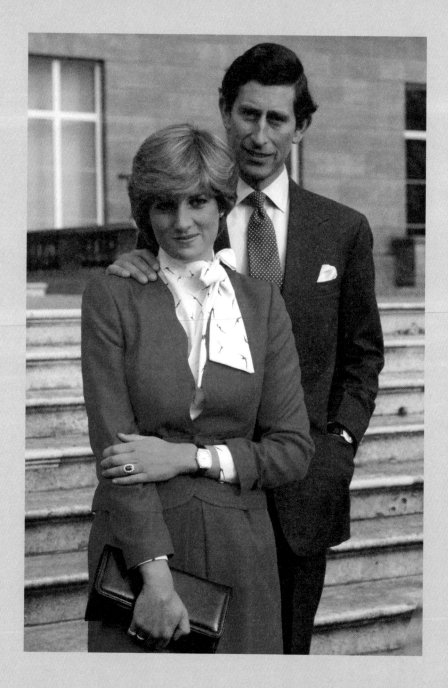

Princess

As Diana prepared for the official photo shoot that would announce her engagement to Prince Charles, she popped into a Knightsbridge boutique, Bellville Sassoon, to find the perfect outfit for the occasion. After all, the image would likely be plastered across tea towels and commemorative plates around the world. No pressure. As she browsed the racks for inspiration, one of the shop assistants, who didn't recognize Diana, informed her that the shop was about to close and recommended that she head to Harrods, around the corner. When they discovered what had happened, the duo of designers behind the label, Belinda Bellville and David Sassoon, quickly called Diana to apologize and welcomed her back to the store. This led to a longstanding relationship with the designers, who would go on to make countless outfits for Diana, including some of her most iconic styles. The charming anecdote highlights the extent of the transformation on which Diana had embarked and the way her world was swiftly changing around her.

In 1981, after just 13 meetings between the couple, Diana's engagement to Prince Charles was announced. Accompanying the announcement came an interview and photo shoot, resulting in images that are now familiar across the globe. Diana looks bashful in a royal blue skirt suit, perhaps chosen to match her sapphire engagement ring or to signify her

Diana wears a royal blue two-piece outfit from Cojana –
a perfect match for her sapphire engagement ring, 1981.

"You could see her go from Shy Di, looking down, to becoming stronger – which she had to do."

ANWAR HUSSEIN

ascension to the royal household. Though it might not have been the first choice of garment for an eighties teen, a patterned pussy-bow blouse endowed Diana with a gravitas far beyond her years – perhaps to subtly emphasize that she was a good match for her fiancé, who was 12 years her senior.

However, the expression on Diana's face immediately betrayed her youth. The couple's somewhat stiff, uncomfortable appearance may have been due to Diana's unease in her formal clothing, her ineptitude in front of the cameras or the couple's lack of familiarity. However, the young bride later offered another explanation for the awkwardness that had been captured on film. In her 1992 memoir, Diana reflected on the moment when, in response to a reporter asking, "Are you in love?" she had answered, "Yes", and Charles, "Whatever 'love' means."

Photographed on a 1981 visit to Balmoral, Diana sports a hot pink Peruvian-style jumper that would spark countless knock-offs for decades to come.

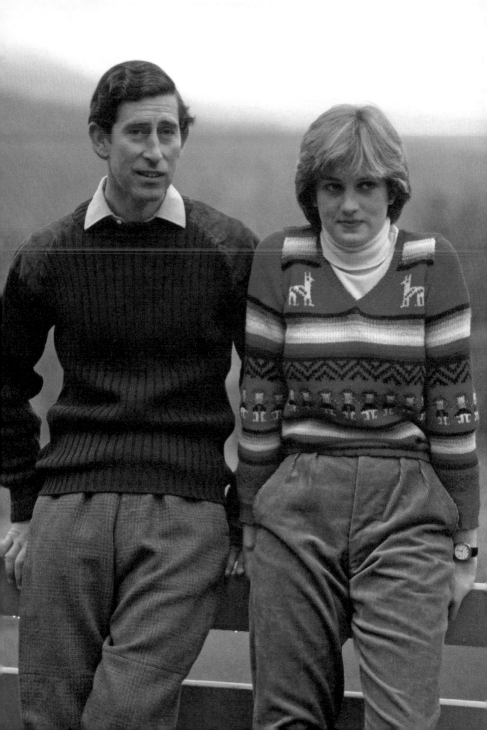

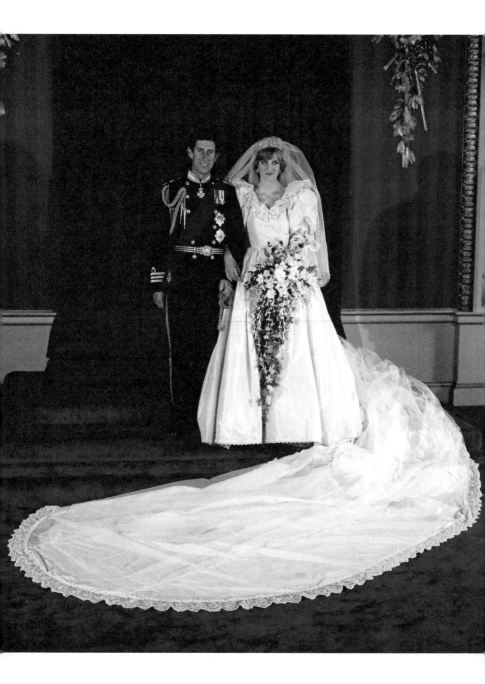

May 1981 marked an important step on her journey to royalty. Charles invited the young Diana to Balmoral Castle in Scotland, one of Queen Elizabeth II's favourite haunts. It's reported that Diana arrived with just a small suitcase for the weekend, which is said to have caused some alarm to those present. Diana may have been perceived as out of her depth, ill prepared for a visit with the Queen of England. Despite this, Diana passed the "meet-the-family" test, and the pair were married a few months later. One of the most famous photographs from the Balmoral trip shows the young Diana in a bright pink patterned jumper, corduroy trousers and Wellington boots from Hunter. These innocent yet confident choices suggest that the prospect of becoming a royal wouldn't phase the young woman.

The costume director of *The Crown*, Amy Roberts, told the *Financial Times* in November 2020, "[Diana] got a lot of grief when she was engaged and went to the palace, people complained [that it was a constant succession of] new outfit, new outfit. And she said, I had to, I didn't have anything. She was going from a teenager into this extraordinarily rarefied world that she wasn't cut out for."

On 29 July 1981, Lady Diana Spencer became Princess Diana, marrying Prince Charles in a ceremony at Westminster Abbey, a spectacle witnessed by a staggering 750 million people around the globe. The dress became an instant symbol of Diana's coming of age, and marked the beginning of a new era in her fashion story.

Diana worked with design duo Elizabeth and David Emanuel to create her show-stopping wedding dress, pictured here on the big day in 1981.

Eleri Lynn, the curator behind the 2018 exhibition *Diana: Her Fashion Story*, told the *Independent* in 2021, "With rolling news, tabloid journalism, and the dawn of the digital age, Diana had to quickly learn the rules of royal dressing, and so the effect of Diana's wardrobe on wider public trends was much more immediate than ever before."

Being pregnant with an heir to the throne wouldn't stop Diana from having fun with her attire throughout 1982. Her maternity style ranged from a now-coveted koala-patterned knitted jumper and corduroy trousers, worn to a polo match in Windsor, to a scarlet chiffon maternity gown by David Sassoon that captivated onlookers at the Barbican Centre on a visit a few months before the princess gave birth to her son William.

The next few years would see Diana becoming more playful with her style, whether by mimicking the colours of the Canadian flag in an outfit worn to an event in Edmonton, Alberta (fun fact – Diana's birthday is the same day as Canada Day), or a stunning one-shoulder dress designed by Bruce Oldfield, which featured a circle print and ruffles.

Maternity style never looked so good. Diana wears a David Sassoon gown while pregnant with William, 1982.

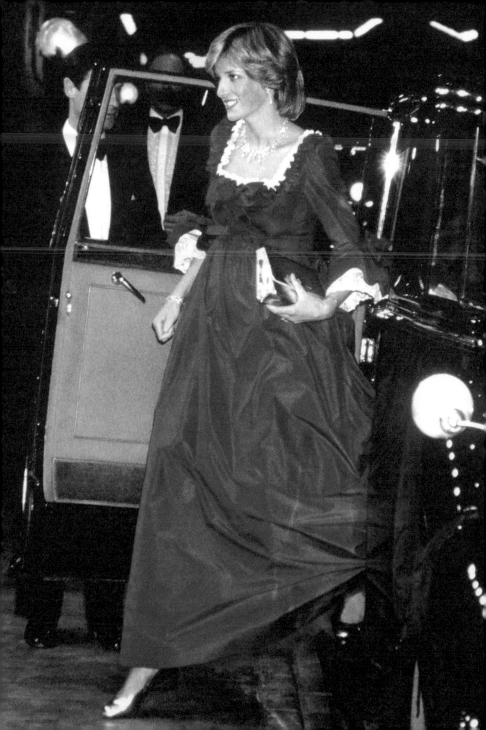

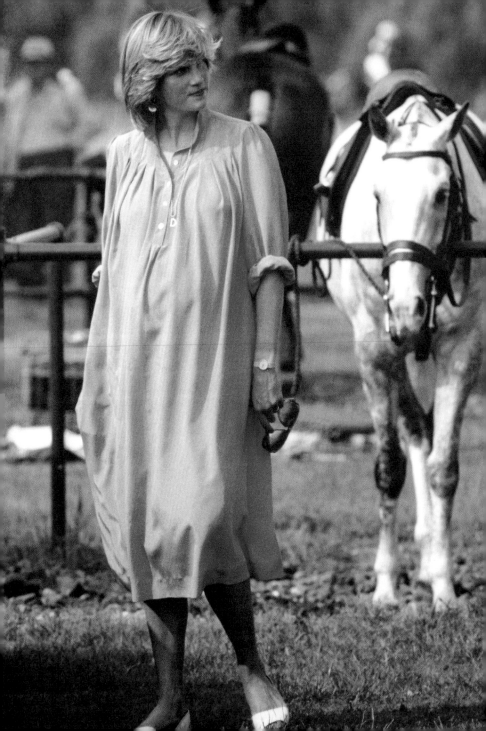

"*It was SO different from today's standard minimalist, fitted maternity wear. Instead, she leaned into trends and really went for it.*"

VOGUE'S EXECUTIVE FASHION DIRECTOR, RICKIE DE SOLE

Diana keeps things casual in a pink shirt-dress look while attending a polo match in 1982.

By 1983, Diana was venturing even further from her humble knitwear-clad days, into a world of extravagant styles that brought serious sartorial energy to the black-tie affairs she and Prince Charles frequented. The woman that the press once referred to as Shy Di due to her meek and naive persona would now be seen as Dynasty Di, a nickname nodding to the hit American TV programme starring Joan Collins and filled with bold colours, ultra sheen fabrics and larger-than-life silhouettes. It was during this period that Charles and Diana undertook a royal tour to Australia, zigzagging around the country and displaying the biggest smiles that the press would ever capture over the course of their marriage. Diana's popularity was hitting new heights – and her shoulder pads were following suit.

In 1989, the princess ventured across the pond on a solo trip, reportedly intended to "promote British industries abroad". (The increasing friction between her and Prince Charles must have provided further motivation to set off alone.) Her three-day tour of New York was an opportunity for her to solidify her role as a style icon – not just in the UK but also internationally. But while the shopping districts and boutiques of Manhattan anxiously prepared for a potential royal visit, Diana proved more interested in participating in philanthropic activities on her trip to the Big Apple. As the American press speculated about which clothing shops Diana would enter, it was clear that she was becoming known for something other than her royal status – or her charity work.

Reinterpreting the Canadian flag, Diana wears a scarlet outfit with statement collar and matching hat during a royal tour of Canada in 1983.

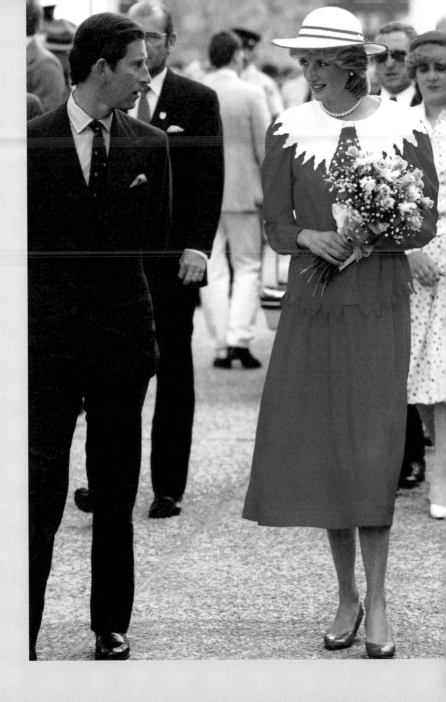

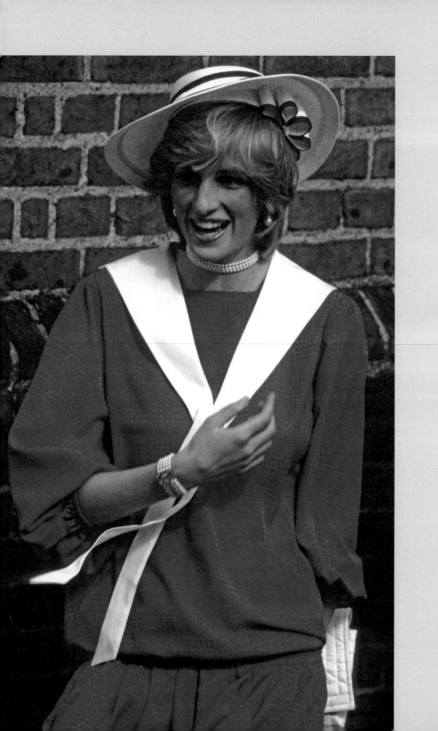

OPPOSITE Early in her pregnancy with William, Diana sports a pink sailor-style dress to attend the wedding of a friend in London, 1982.

ABOVE Diana attends a charity event at Barnardo's, where she chats with Joan Collins and designer friend Bruce Oldfield, 1985.

"*It is said she was* more beautiful *in the flesh. Once, on a visit to Vogue, the art department, who'd been quite cynical about her, were agog.* She had sparkle. *It was* simply magnetic *and, in the end, it transcended her* clothes."

ANNA HARVEY, *VOGUE*

Diana's right-hand women

Diana was to become known for her individuality and desire to do things her own way. But when it came to fashion, she wouldn't have been able to advance from Sloane Ranger to one of the most admired fashion icons of her time without a little help. That's where Anna Harvey came in. First crossing paths in 1980, the editor of British *Vogue* and the Princess of Wales were to form an unbreakable relationship that would continue until Diana's final days. It was Anna who introduced Diana to designers who would go on to become her favourites, including Catherine Walker, the French-born designer who many believe was Diana's sole dresser in her later years.

On Walker's passing in 2010, Anna Harvey told *Vogue*, "What Catherine did was take a girl who was essentially a Sloane Ranger before her marriage, and design for her in a straightforward, streamlined, beautiful way, with consideration of all the royal occasions."

Diana's relationships with her favourite designers were rumoured to be some of the closest she had. Bruce Oldfield, Gianni Versace, David Sassoon, Jacques Azagury and Elizabeth and David Emanuel have all spoken about their time working with her. Remembering one of their first meetings, David Emanuel recalled, "[Diana was] the most beautiful woman, inside and out. It [wasn't] just the look and the frocks and the fashion. She genuinely was

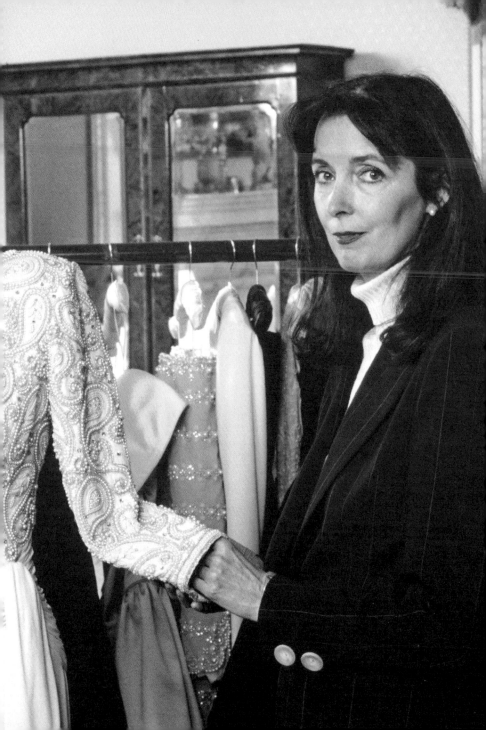

just sweet. She was very young." Catherine Walker loyally denied any and all opportunities to speak about Diana to the press.

Many of these fashion designers offered Diana an escape from her increasingly overwhelming life in the public eye, and each one helped her blossom into an icon.

"I thought she was a bit lost. But she soon became entirely empowered through fashion. It gave her a stay, and an armour, to mask a sadness. I think an enormous chasm opened up between the girl hidden inside and the different woman she had to create and present to the world," designer Arabella Pollen told *Vogue* in 2017.

Another important name in Diana's style journey was Liz Tilberis. The two met when the editor worked at British *Vogue* and Diana was first delving into the fashion world. Tilberis would go on to become editor-in-chief of *Harper's Bazaar*. The friendship is said to have become closest in the final decade of Diana's life, when her relationship with Charles was coming to an end and Tilberis was undergoing chemotherapy for ovarian cancer. It was alongside Tilberis that Diana would attend the Met Gala in 1996, wearing one of her most famous looks.

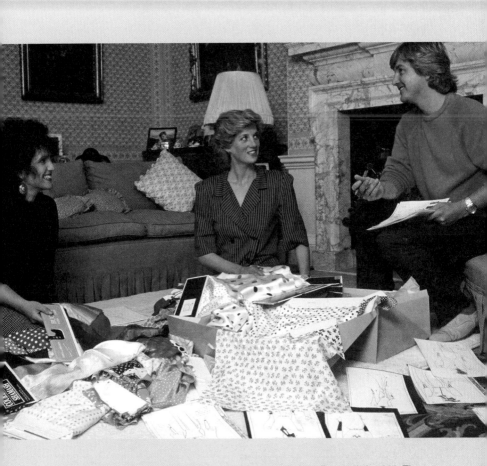

ABOVE Diana reviews fabric swatches with designer duo the Emanuels in 1986. The pair designed some of Diana's most iconic looks, including her wedding dress.

PREVIOUS Long-time friends and collaborators Diana Spencer and Catherine Walker pose with a dress at Kensington Palace, 1993.

ABOVE David Sassoon was known to be one of Diana's favourite
designers. The two are pictured here at a charity event in 1997.

RIGHT One of the rumoured 70 sketches that David Sassoon
made for Diana when designing outfits for the princess.

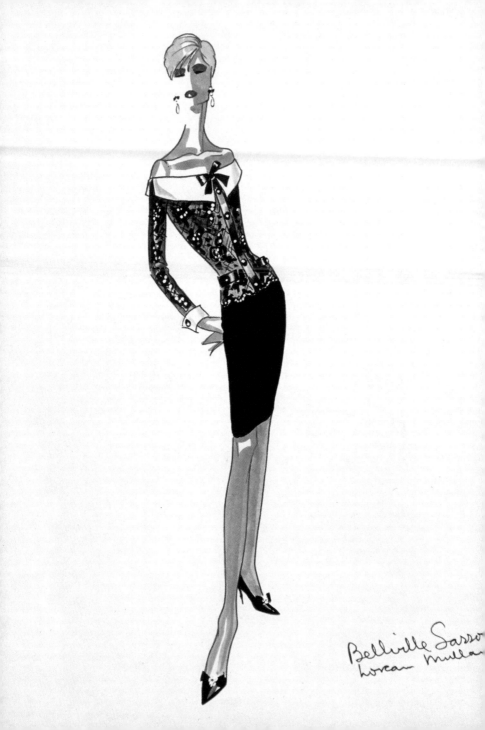

Bellville Sasso
Lorcan Mulla

Independence

Diana was known to play with both official and unspoken sartorial rules while married to Prince Charles. Once their relationship ended, the rule book was thrown away completely. As the nineties pushed many fashionistas into new realms of experimentation, using garments as a means of self-expression, Diana's wardrobe too became a hotbed of messaging around her newfound independence.

"She had turned into a woman who was quite assured in her work. Who was brave and headstrong," says Jasper Conran. "The simpering princess had gone. She was not playing a part anymore. She'd found a role."

But it wasn't just her outfits that helped her explore her autonomy. Her hairstyle also played a key role in her transformation. When asked about a moment in her life when she went from "victim to victor", Diana explained that an impromptu haircut in 1991 by Sam Knight changed the game. "I suppose last summer when Sam cut my hair differently," she said, "it let out something quite different." Though it would be another couple of years before the royal couple would announce their separation, many recall the period following the haircut as a time when Diana began to move into a new era of confidence and self-assurance.

"She had turned into a woman who was quite assured in her work. Who was **brave** and **headstrong** ... The simpering princess had gone. She was not playing a part any more. She'd found a role."

JASPER CONRAN

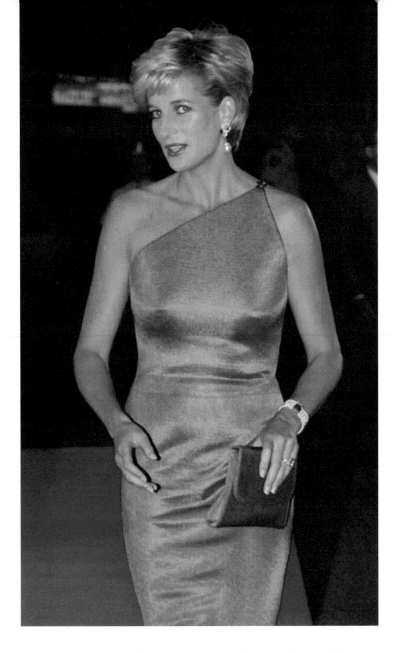

Diana steps out confidently in a turquoise silk dress by Versace, 1996.

Diana and Charles separated in 1992 and went on to divorce in 1996. In the UK, 1992 and 1993 saw the highest rate of divorce there had ever been before – or has been recorded since. High-profile couples, from Princess Anne and Mark Phillips to Hollywood royalty Johnny Depp and Winona Ryder, were calling it quits (OK, the latter weren't actually married but for many teens of the time, they were the only couple who really mattered). It was a time when many women were experiencing a buzzing energy and a powerful sense of, well, being able to do whatever they bloody wanted. And that included breaking all the style rules.

Drag queen, performer and fashion personality Bimini said of the royal, "I feel like as Diana got more comfortable and confident in the public eye, she really knew that she was able to use the way she dressed to make a statement without having to outwardly say anything. It wasn't about being outrageous. She wasn't walking around with a lantern on her head but she would always wear something and be a bit daring and she used it to be a bit provocative. She was a cheeky lady, Diana. And she knew how to push the establishment's terms, and the media, and use it to her advantage."

At this time, Diana embraced the dramatic contrast between glamorous high-fashion style and off-duty jeans and sweats. Her red-carpet styles shone brightly with extravagant diamonds and pearls, her hemlines were shorter than she would have dared to wear before and her skinny shoulder straps were the height of fashion. She proudly sported styles from names like Versace, Jacques Azagury and Moschino – a wardrobe that many leading actresses or pop stars of the time would gladly have adopted. The impact of royal life was

"*She could walk into a room of people and make them feel* as *if everything was great.*"

ELTON JOHN

Princess Diana and Mother Teresa at the Missionaries of Charity in New York, 1997.

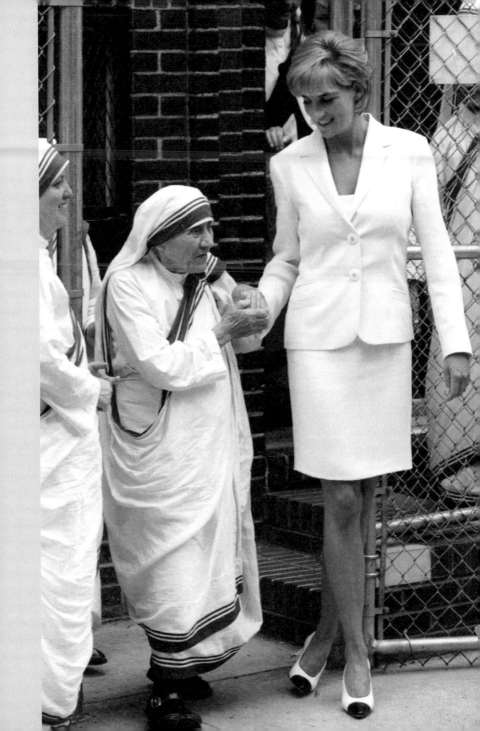

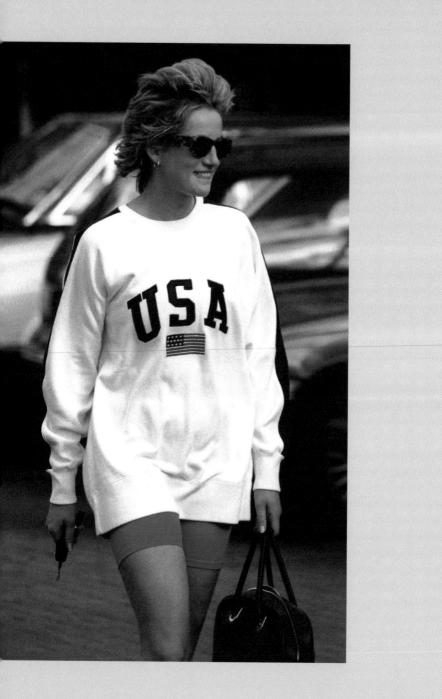

nowhere to be seen. Diana was relishing the chance to engage fully with all the weird and wonderful nineties trends – with her own twist applied, of course.

"She was comfortable in multiple versions of herself. I think that's also something that's common today – not wanting to be one version of yourself as a woman. You want to inherit all of them. There was definitely a power in that effortlessness," said associate costume designer and head buyer on *The Crown*, Sidonie Roberts.

When she wasn't visiting war-torn countries on humanitarian missions or at a gala to raise money for cancer research, one of Diana's favourite activities in the nineties was visiting her local gym for a good old sweat session. Arguably one her most famous looks today remains an ensemble made up of spandex cycling shorts and an oversized cotton crew-neck sweatshirt, worn to journey to and from a training session at The Harbour Club in London's Chelsea neighbourhood.

Whether it was down to a new haircut, new hobbies or a newly ditched man, Diana entered the later years of the nineties invested with an unfamiliar, hard-earned independence. She had never been an adult in the public eye without the watchful, overbearing protection of one of the most powerful institutions in history. The most famous woman on the planet was now single and the world waited with bated breath to see what her next move – and her next look – would be.

One of many Diana gym looks that continue to inspire copycats decades later, 1997.

Diana's

CHAPTER 2

Greatest Hits

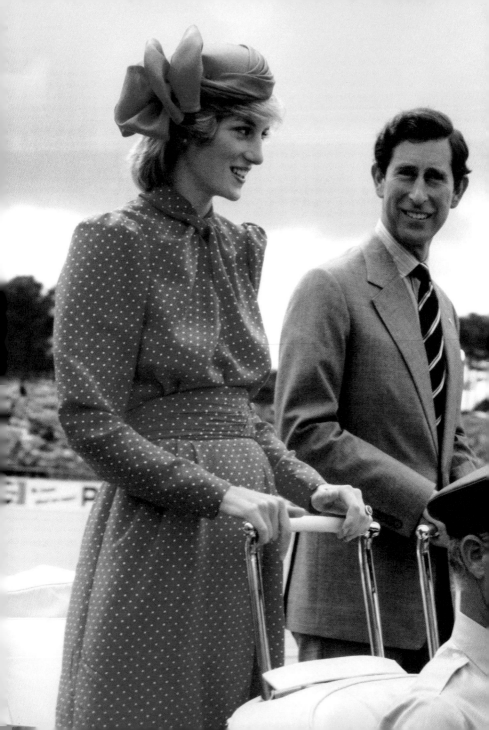

Narrowing down Diana's most impactful looks over nearly 20 years in the spotlight is no easy task. Each of her outfits tells an important part of her story. Taken together, they weave a tale that combines deep sadness and electric inspiration. Often the messages she was sending through her style were considered and a conscious choice of a tactical way of using her voice without speaking, whereas other times the clues of significance would be woven by the onlookers, and often in hindsight some years later.

Elizabeth Debicki, who depicted Diana in season five of *The Crown*, commented, "It's an extraordinary thing to watch. To decide what you're saying about yourself through fashion ... it was a currency. An incredibly powerful currency."

The royal years

Diana's days as HRH Princess of Wales were a rollercoaster of highs and lows, as she struggled to navigate media scrutiny, motherhood and royal practices. While most twenty-somethings were furthering their careers and beginning to consider marriage and parenting, Diana was having to navigate royalty and parenthood in front of a global audience – and the press weren't being very forgiving. As she began to come into her own, so did her sense of style. What began as a dedication to ultra-feminine gowns, florals and flouncy fabrics shifted into a love of sharp tailoring, high-fashion frocks and playful

Diana wears a polka-dot dress by Donald Campbell and a John Boyd hat on a visit to Perth, Australia, in 1983.

"So many people supported me through my public life and I will never forget them."

PRINCESS DIANA

An angelic Diana poses for a portrait wearing a frill-collar top and pearl earrings, 1983.

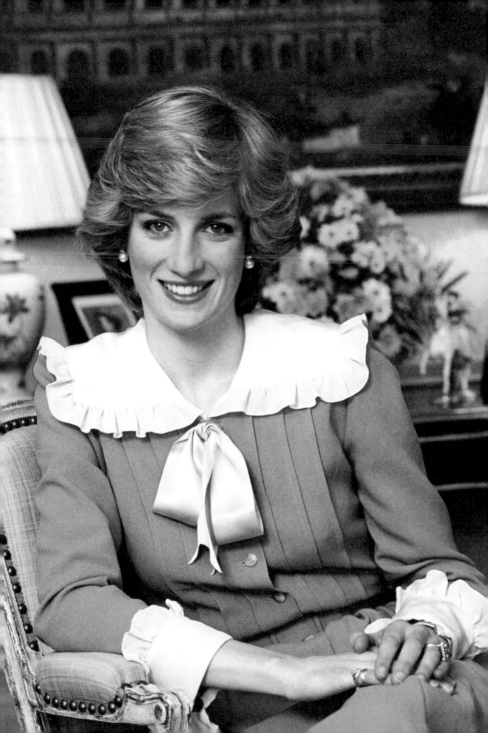

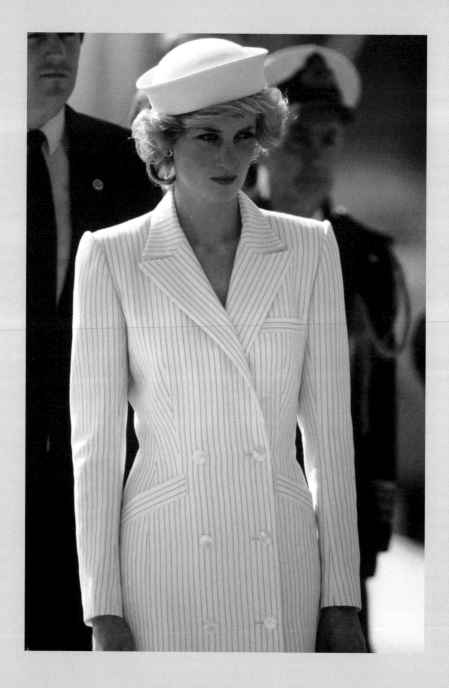

androgyny. Whenever Diana stepped out at an event or went on a school run, the world scrutinized her outfit and took every opportunity to dissect its meaning.

Proving that she could fuse princess elegance (that fascinator) with on-trend looks (the eighties were liberally sprinkled with polka dots), Diana stepped out to visit the Fremantle Hospital in Perth, Australia, on a royal tour that demonstrated serious style. The dress, created by Canadian fashion designer Donald Campbell, featured a soft silhouette with puff shoulders, a curved hem and a gathered waist. The accessories included a simple white clutch and a pillbox hat with statement bow designed by the respected British milliner John Boyd.

Catherine Walker does what she does best in the design of this totally timeless blazer dress, worn by Diana at a naval base in La Spezia during the royal tour of Italy in 1985. The pinstripe style features a double-breasted fastening and an exaggerated lapel – because why not? But arguably the best part of this outfit is the Kangol hat. The cult British brand would go on to cover the heads of basically every celeb throughout the nineties and early two thousands with its bucket hats and flat caps, which featured that famous kangaroo logo. Seems like the logo didn't make it onto Diana's hat, but it's definitely proof that she was ahead of her time.

Catherine Walker gets the credit for this double-breasted number, styled here with a Kangol hat on a royal tour of Italy, 1985.

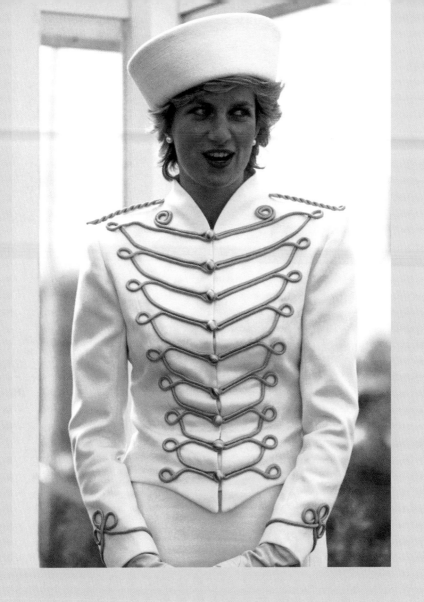

OPPOSITE During the Royal Tour of Italy in 1985, Diana wears
a Catherine Walker dress and hat by John Boyd.

ABOVE Diana works a military look in a Catherine Walker dress
while visiting Sandhurst Military Academy, 1987.

"*I don't go by the rule book.*"

PRINCESS DIANA

A black and yellow coat by Escada and a Philip Somerville hat
help Diana shine on a visit to the Isle of Wight, 1988.

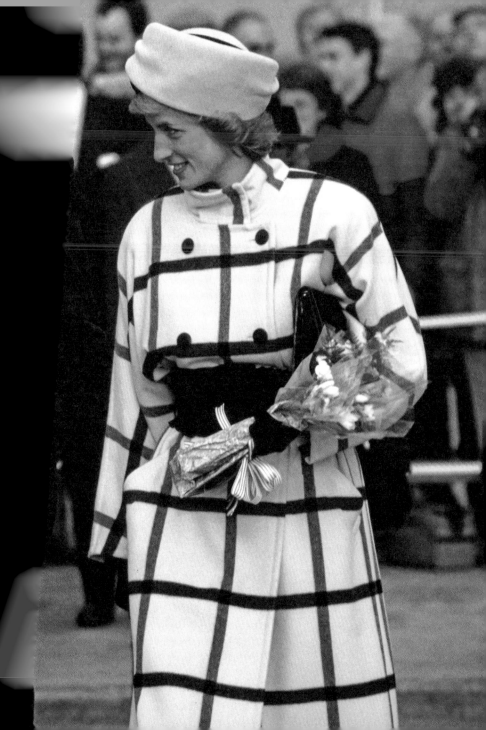

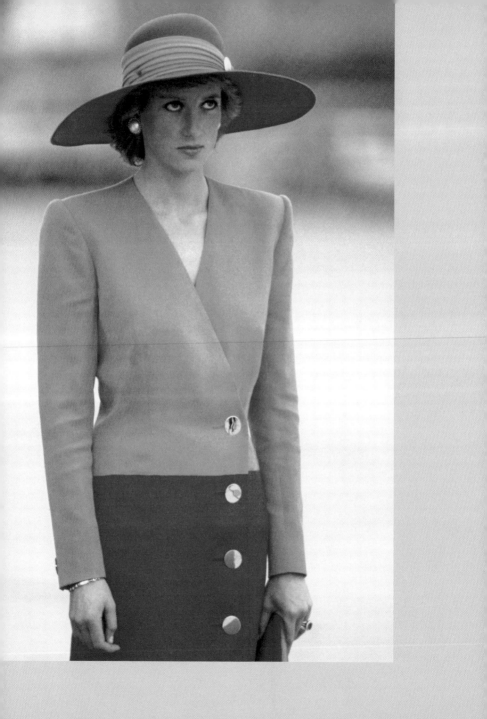

Was Diana the first devotee of dopamine dressing? She might well have been. Anyone's mood would be lifted by the striking pairing of hot pink and red in this Catherine Walker design, which Diana wore on a visit to Abu Dhabi, United Arab Emirates, in March 1989. The look was styled with a wide-brimmed hat made by Philip Somerville. The royals' favourite milliner created a pink ribbon that wrapped around the design, fastened with a gold pin, to match the dress perfectly. This look completely flouted fashion's unwritten rule that pink and red should never be paired.

Over 30 years on, we still see the former fashion *faux pas* standing the test of time, as names like Giambattista Valli, Rick Owens and New York designer Mara Hoffman demonstrate their obsession with the colours in their recent collections. Mara Hoffman has even managed to fuse two of Diana's most brilliant fashion legacies – the pairing of red and pink and the tank dress – into one item with her Sloan Dress (a play on Sloane, as in Sloane Ranger? Maybe).

Diana ditches outdated fashion rules in a red and pink Catherine Walker dress and statement hat by Philip Somerville in Abu Dhabi, 1989.

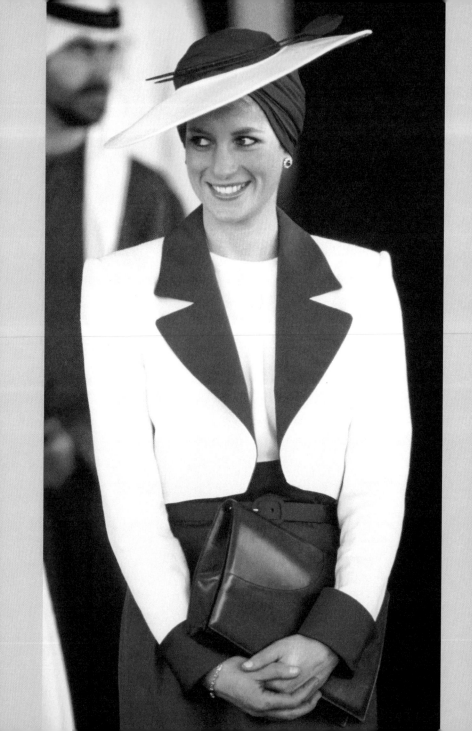

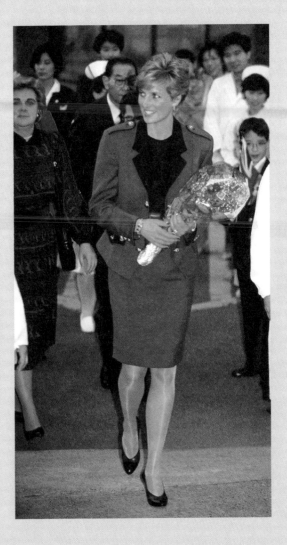

OPPOSITE A turban hat by Philip Somerville got the nod of approval from fashion lovers across the globe when Diana wore it alongside a Catherine Walker design during her visit to the Middle East in 1989.

ABOVE Diana looked to Italian fashion house Moschino for this olive-green two-piece outfit worn on a trip to Tokyo in 1990.

"*I knew what my job was; it was to go out and meet the people and love them.*"

PRINCESS DIANA

For the first Christmas after her separation from Charles, Diana wore a striking red coat, black dress and a black hat complete with a veil. This look would become the inspiration for one of the key ensembles worn by Kristen Stewart in the 2021 film *Spencer*.

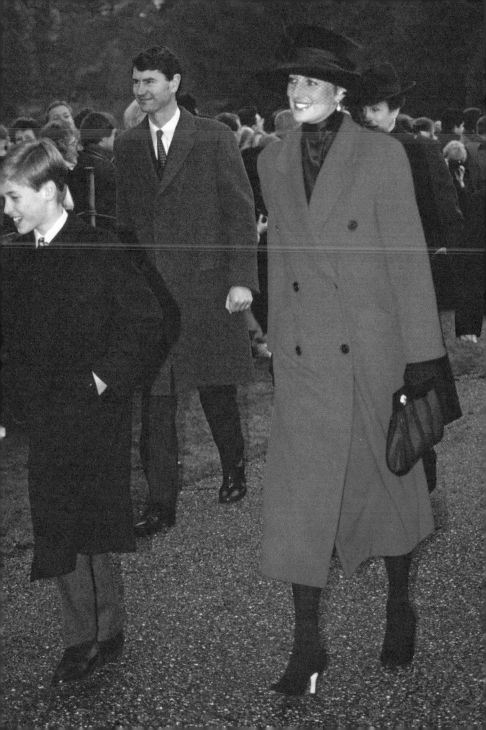

Glamour

Before she found herself married to an actual prince, Diana Spencer's opportunities to sport lavish gowns and diamond-studded, floor-grazing dresses were pretty slim. As she gained comfort and confidence in the public eye, the glamorous looks became more commonplace in her ever-growing wardrobe. The details of Diana's most eye-catching looks would become key signifiers in the story of her life, through her coming of age, womanhood and motherhood, and later, as she found true independence as a confident single woman. Here we explore some of those key looks and their significance.

Imagine your chosen date outfit causing such a stir that the UK government had to postpone announcing the budget for the year because the press was having a field day. That's the kind of impact Diana made on the media in 1981, before she had even married Prince Charles. It was the couple's first official engagement together, a trip to a charity gala concert at the Goldsmiths' Hall, and understandably, Diana wanted to look her best. She had approached designers Elizabeth and David Emanuel to create a gown made of pastel-hued netting that aligned with her angelic look at the time. But the story goes that when Diana spotted a strapless black number on the rail of the designer duo's Brook Street showroom,

Diana hit the headlines in this black gown by David and Elizabeth Emanuel, worn on the young couple's first official outing in 1981.

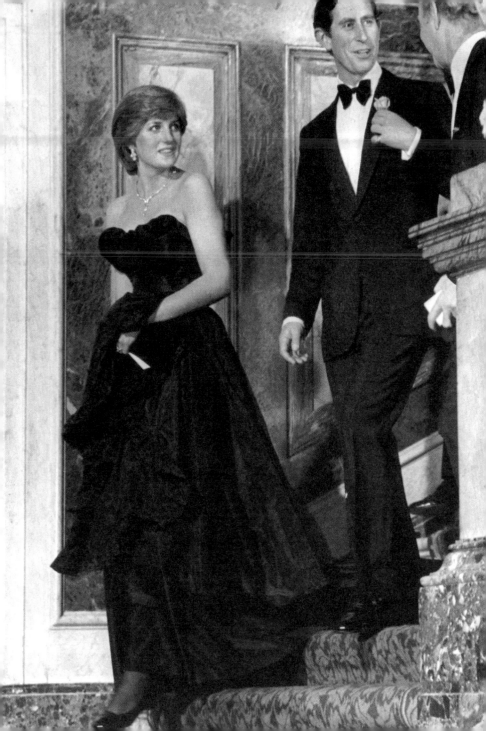

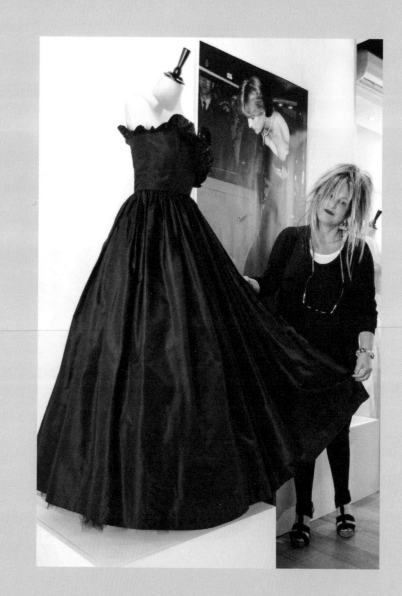

Elizabeth Emanuel proudly presents the gown that would go down in history as one of Diana's most iconic looks. The design sold for nearly £200,000 at an auction in 2010.

the plan of arriving pretty in pink was quickly forgotten. It's likely that, with her limited experience in the limelight, she would have been unaware of the impact this dress would have, not only on the press and avid onlookers of the time, but on fashion history.

The taffeta style showed off Diana's slender shoulders and featured a sweetheart neckline with frills as far as the eye could see. The royals are known for their strict dress codes – one being that black is reserved for periods of mourning. Though quiet and shy, Diana dressed as she pleased that evening. It was an early hint of the rebellious approach she would take in years to come. For many, this moment took Diana Spencer to fashion icon overnight. And we can see why.

On 29 July 1981, Diana Spencer became Diana, Princess of Wales. Such an occasion would call for a wedding dress unlike any other. It's rumoured that hundreds if not thousands of pitches arrived at the palace as designers bid for a chance to design the dress that the world would admire on that summer's day. But for Diana, the choice was obvious.

Diana had collaborated with the Emanuels on a number of head-turning styles already and she was keen to continue their working relationship. The next piece she commissioned from them would change their lives completely.

"It happened out of the blue. She rang my studio and said, 'Would you do the honour of designing my wedding gown?'" David Emanuel recalls. Work quickly began on a dress that would impress a staggering audience, 750 million people, who would tune in to watch the wedding from across the globe.

One of the closest-guarded designs in fashion history, the dress Diana Spencer wore to wed Prince Charles on 29 July 1981 was a tour de force. Featuring multiple romantic details, it conjured up the essence of the fairy tale that Diana had been promised her life would become.

The brief for the dress was, well, non-existent. Elizabeth Emanuel told *People* magazine in 2018, "[Diana] was just lovely, really kind of easy going. We never had any special instructions about how to make the wedding dress. That added a bit to the fun of it all, made it bit of an adventure."

The stunning silk gown featured a ruffled collar, puffed sleeves (ever popular in the eighties), a voluminous skirt decked with approximately 10,000 pearls and an 18-karat-gold horseshoe charm, which was secretly sewn into the body of the dress for good luck by the Emanuels. But probably the most famous feature of the dress was the 25-foot train that covered the aisle of Westminster Abbey and tulle veil that spanned 153 yards (almost 140 metres). The train continues to hold the record as the longest in royal history. Sewn into the design was antique Carrickmacross lace, which had belonged to Queen Mary (and which represented the "something old" that tradition dictates all royal brides should have in their wedding dress).

Tying the look together was a garland-style tiara, made in 1930, from diamonds belonging to the Spencer family, by famous Mayfair jeweller Garrard. Diana's mother Frances Shand Kydd lent Diana her earrings for the big day. A central pear-shaped diamond was surrounded by smaller diamonds to add extra shimmer.

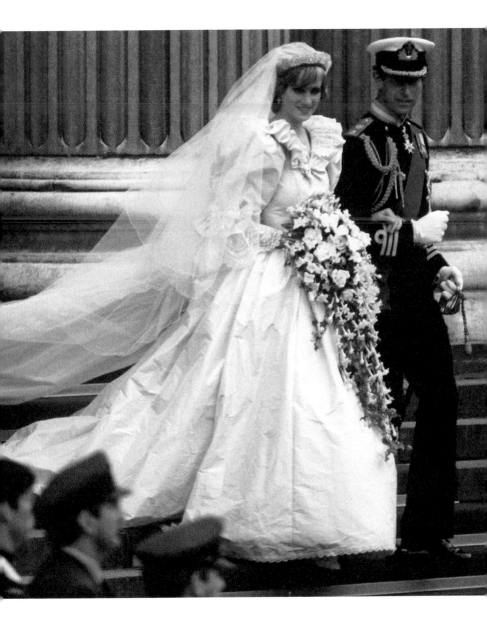

Diana becomes the Princess of Wales in a dress designed by the Emanuels, 1981.

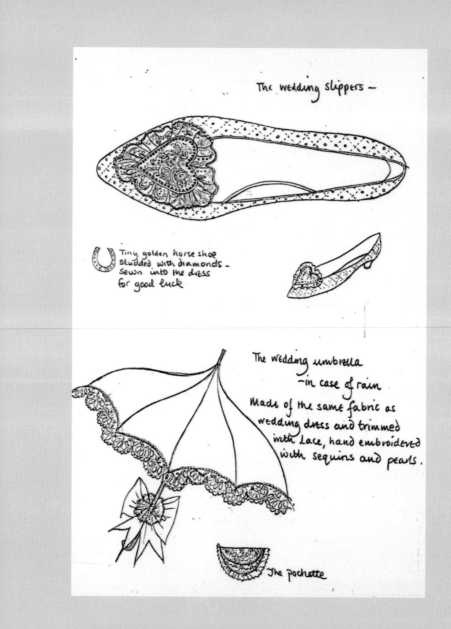

The wedding slippers —

Tiny golden horse shoe studded with diamonds - sewn into the dress for good luck.

The wedding umbrella
—in case of rain.
Made of the same fabric as wedding dress and trimmed with lace, hand embroidered with sequins and pearls.

The pochette

A sketch by the Emanuels depicting Diana's wedding shoes and a bespoke umbrella design that was to be used in case of rain on the big day.

Elizabeth Emanuel worked with renowned UK cobbler Clive Shilton on the silk satin shoes, which were covered with 542 sequins and 132 seed pearls and displaying a heart motif on the toe. The heel was kept low (to ensure Diana didn't tower over Prince Charles), a decision that *Vogue France* described as "a hymn to romance". "The gesture symbolized great tenderness and a note of naivety from a woman who did not yet know what the future held for her and the prince she loved," stated Anna Maria Giano, editor at *Vogue Italia* in an online piece in July 2022.

The dress created such a buzz in the bridal gown industry that replica designs were popping up mere hours after the wedding. Just days later, copycat styles were on display in shop windows.

Diana's beauty was captured in repose when she managed to catch a few zzzs while attending an event at the Victoria and Albert Museum in London four months after her wedding to Prince Charles. The famous photograph shows the Princess of Wales in a flowing off-the-shoulder Bellville Sassoon dress with a hand-painted pattern, satin trim and ruffled hem. Diana's pearl choker, which was becoming something of a trademark piece for the princess, was matched with a statement bracelet and matching earrings. As much as we'd love to say that this was another cheeky way to show the royals that she played by her own rules, the palace announced the next day that the 20-year-old, freshly dubbed "Sleeping Beauty" by the press, was in fact exhausted because she was in the early stages of pregnancy with Prince William.

OVERLEAF The famous dress was available for the public to inspect at *Royal Style in the Making*, an exhibit at Kensington Palace, 2022.

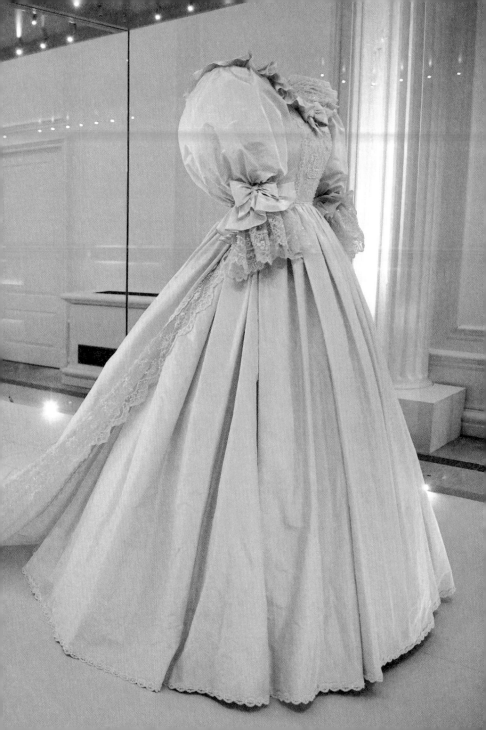

"It took a long time to understand why people were so interested in me."

PRINCESS DIANA

"Sleeping Beauty" Diana opts for a pretty pastel Bellville Sassoon style
for an outing to the Victoria and Albert Museum in London, 1981.

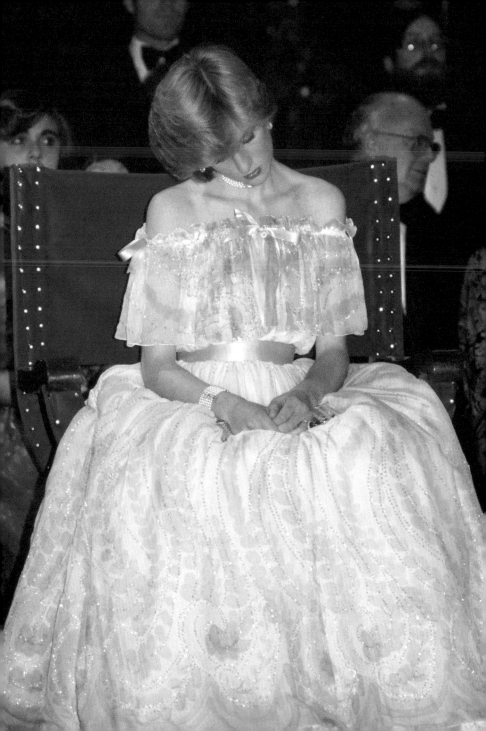

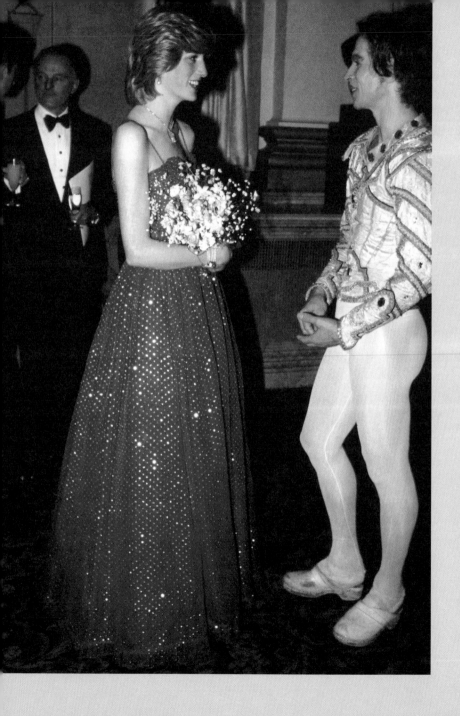

OPPOSITE Diana shimmers in a red Bellville Sassoon dress while
attending a ballet performance at the Royal Opera House, 1982.

ABOVE Feminine frills make this Emanuel design
pop on a visit to Claridge's Hotel, 1981.

Diana had an affinity for shimmering styles with serious eighties charm. A key example of Diana's affinity for shimmering styles with serious eighties charm, the Bruce Oldfield number (seen right) made headlines during the couple's 1983 tour of Australia. The new parents made the most of their evening at a charity gala in Sydney by dancing the night away (one of Diana's favourite pastimes).The aquamarine style featured all-over ruffles, metallic thread and a floor-length hem. A bold, metallic leather belt and heels tied things together. Lady Di was adorned in a glittering diamond necklace with matching earrings and bracelet. Recognize the look? A rendition made its way into season four of Netflix's *The Crown*.

On the final night of the six-week tour, Prince Charles and Princess Diana attended a dinner in Melbourne, Australia, where Diana presented herself in a stunning single-shoulder dress designed for her by independent Japanese couturier Hachi. The dress, which had been suggested to Diana by Anna Harvey, was made of white silk and featured silver bugle beads and medallion appliques at the gathered hip and shoulder. The dress would be one of the princess' favourites. She wore it again later the same year, for a second time in 1985 at the National Gallery in Washington, DC, and for a third time in 1989 for the London premiere of the 16th film in the 007 series, *Licence to Kill*. The dress sold at auction for $60,000 (the equivalent of around £85,000 in 2022) in June 1997, just a few months before Diana's death in August of the same year.

The Crown fans may recognise this dress: it inspired a style seen in season four. The original, seen here, was designed by Bruce Oldfield and is styled with a bold silver-tone belt and matching pumps, 1983.

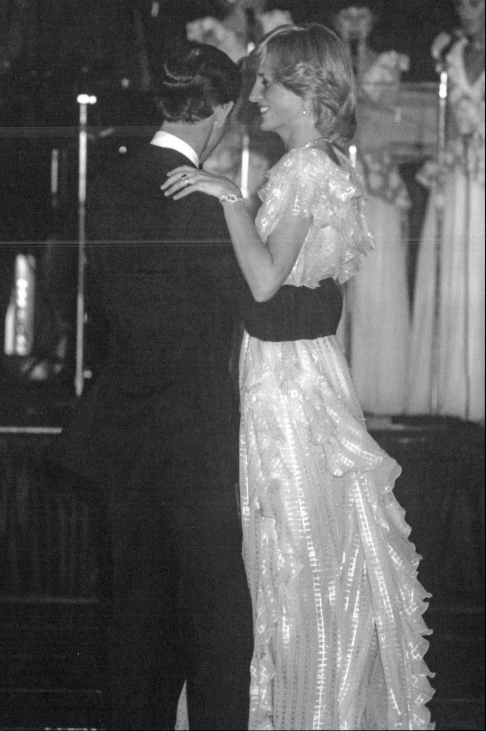

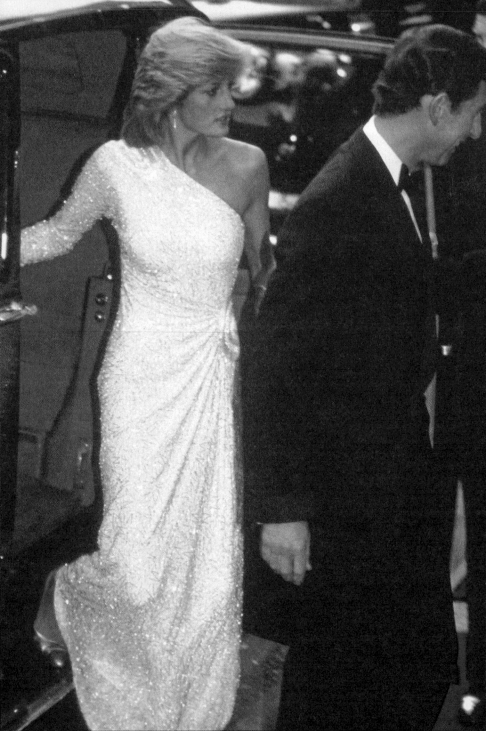

"*I have a woman's instinct and it's always a good one.*"

PRINCESS DIANA

The Japanese designer Hachi is credited for this one-shoulder dress
worn by Diana to a film event in Leicester Square, London, 1983.

Visiting The White House in 1985, Diana wore what would become one of her most famous dresses. The navy number was created by one of Diana's favourite designers, British couturier Victor Edelstein, reputedly after Diana spotted a burgundy version in his studio. The Princess of Wales requested that Edelstein create a version for her in one of her favourite colours, midnight blue. The fitting for the dress reportedly took place at Diana's suite in Kensington Palace, where the princess was so thrilled with the result that it's said she immediately rushed off to show the style to Prince Charles.

Diana rapidly learned how to make an impact. She knew that the midnight-blue velvet dress by Victor Edelstein, which she wore when she danced with John Travolta at the White House, was one heck of a number – and it thrilled her.

A big cinema buff and music fan, the princess was honoured to meet John Travolta at The White House. The actor was known for his dancing skills, which he'd demonstrated in leading roles in films like *Saturday Night Fever* and *Grease*. It's rumoured that Mr Travolta had caught wind that the Princess of Wales was interested in dancing with him. Following a tap on the shoulder and a polite request, Diana accepted a dance to the Bee Gees' song "You Should Be Dancing".

OPPOSITE The Princess of Wales attends a gala ballet performance in Auckland, New Zealand, wearing a lilac gown by Donald Campbell, 1983.

OVERLEAF This Victor Edelstein gown would come to be known as simply the "Travolta dress", after Diana captured the attention of the world by dancing with the American actor at a White House event in 1985.

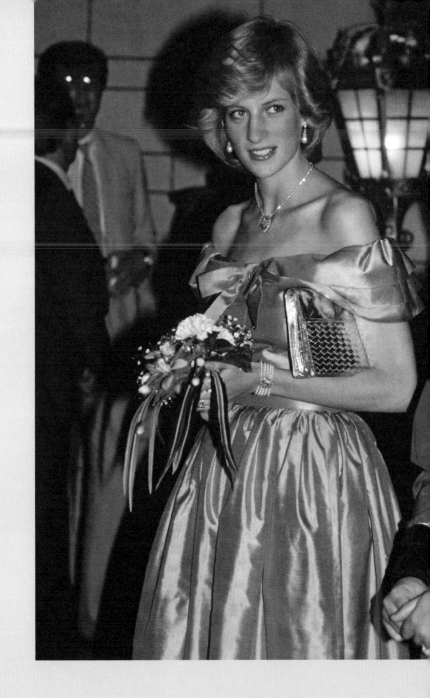

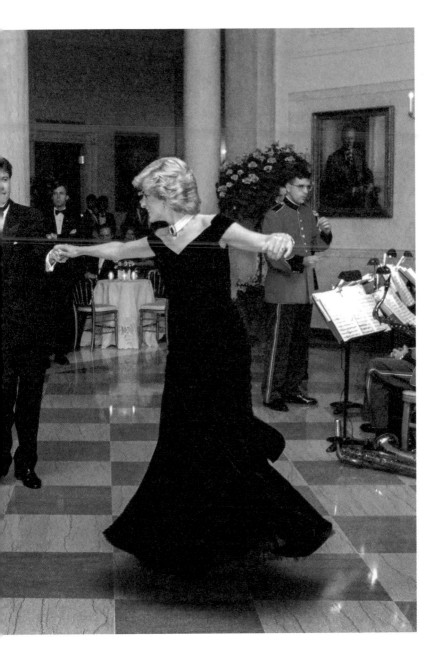

But it wasn't just the midnight-blue dress that captured the attention of onlookers that night. The princess also wore a magnificent choker featuring seven rows of pearls and a blue sapphire surrounded by shimmering diamonds. The sapphire was reported to have been given to the young princess by the Queen Mother in the form of a large oval sapphire and diamond brooch: a wedding gift to her new granddaughter-in-law. The accessory was evidence of Diana's creative flair for playing with fashion, and it became a key piece for the princess, worn for the next decade (and making an appearance alongside her "revenge dress" and 1996 Met Gala look). Wearing your ex's nan's jewellery to a high-profile event after your break-up is a serious power move.

In early 1989, Diana took a solo three-day trip to New York, an event that Netflix's *The Crown* references in season four. On her second evening in the city, she attended a gala dinner at the World Financial Center's Winter Garden wearing a Victor Edelstein gown with matching bolero. The white satin outfit was covered in beaded detailing and is said to have captivated nearly everyone in attendance.

"Since it was New York, everyone was wearing black [...] So when Diana entered the box, radiant in a magnificent long white dress with a matching bolero jacket covered in jewels, a gasp went up from the crowd," Brooks Hopkins told *People* magazine in 2020.

Diana arrives to see the Welsh National Opera Gala production of *Falstaff* wearing a pearly white dress designed by Victor Edelstein, 1989.

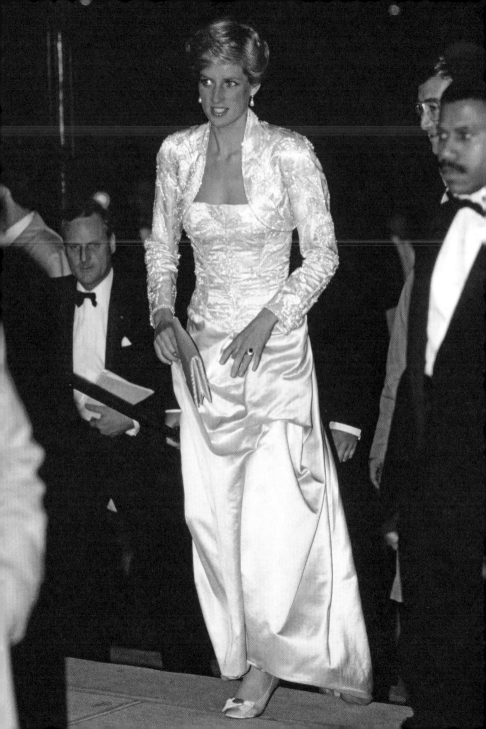

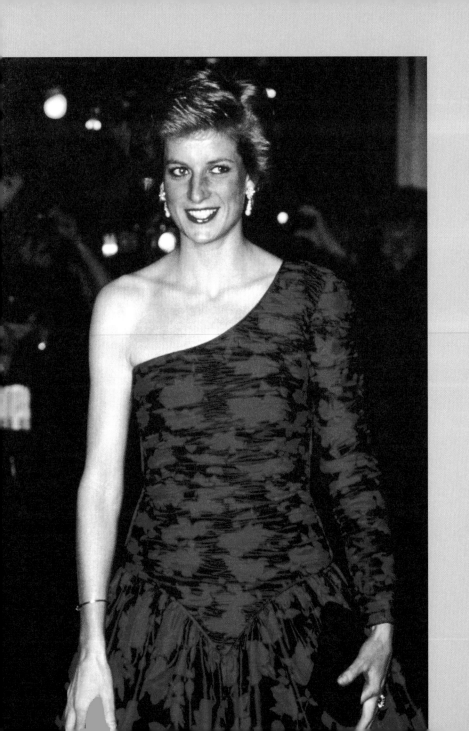

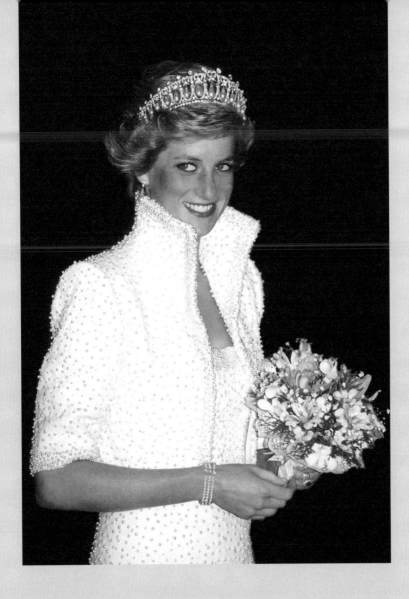

OPPOSITE Diana wears a red and black floral gown by Catherine Walker
to an event at the British Embassy in Paris, France, 1989.

ABOVE The "Elvis dress" by Catherine Walker helped secure Diana's spot
as one of the world's most fashionable women, seen here in 1989.

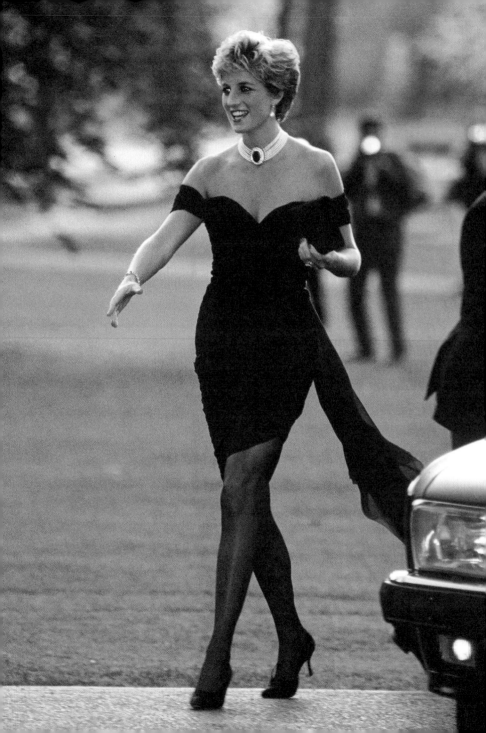

It's impossible to analyze Diana's approach to style without mentioning the "revenge dress". We can speculate at length about the significance of the looks she wore throughout her life, trying to decipher what the princess might have meant by them, but the message of this outfit arrives loud and clear.

Diana made history with her wardrobe on 29 June 1994. Prince Charles had just made headlines with his interview at Highgrove House, in which he came clean about his affair with Camilla Parker-Bowles (though the *New York Times* had leaked his revelation two days before the interview aired). That same evening, Diana attended an event hosted by *Vanity Fair* at the Serpentine Gallery in London's Hyde Park. Her striking little black dress was by Christina Stambolian, a Greek designer. It featured a figure-hugging silhouette crafted from delicate crepe with cap sleeves (which Diana wore off the shoulder), a ruched bodice and flowing black chiffon sash.

The *Telegraph* commented, "The Princess of Wales did not have to dine out before the television cameras at the Serpentine Gallery last night in order to avoid seeing her husband sharing his soul with the nation on the box. She could have watched a video, played bridge, or simply washed her hair and curled up in bed … It's amazing what some people will do to avoid press speculation."

Diana makes fashion history in this Christina Stambolian dress, which became known as the "revenge dress", when she wears it to an event at the Serpentine Gallery in 1994.

"*I can't really explain it. It's pretty incredible that a dress would represent a moment in history... that this human's life would represent so much and become so iconic.*"

ELIZABETH DEBICKI

The legacy of the dress lives on. 29 June will forever be known as "revenge dress day", as highlighted by an Instagram post from the *Telegraph*'s style section on the date in 2020, reading: "Happy revenge dress day (emojis). 26 years ago Princess Diana wore her famous LBD by Greek designer Christina Stambolian to the Serpentine Gallery party (emojis). Click the link in bio for why Princess Diana's revenge dress is still relevant."

Elizabeth Debicki, the lucky Australian actor who portrayed the "People's Princess" in season five of *The Crown*, was interviewed in the press about what it was like to recreate the iconic look. "It fascinated me how entranced people were with that dress," she recalled to *Entertainment Weekly* in October 2022. "When it became known that I had the part, I received these text messages saying congratulations, [but] there was also a huge amount of text messages about the revenge dress. 'Do you get to wear the revenge dress?' 'Oh, my God, you get to wear the revenge dress!'"

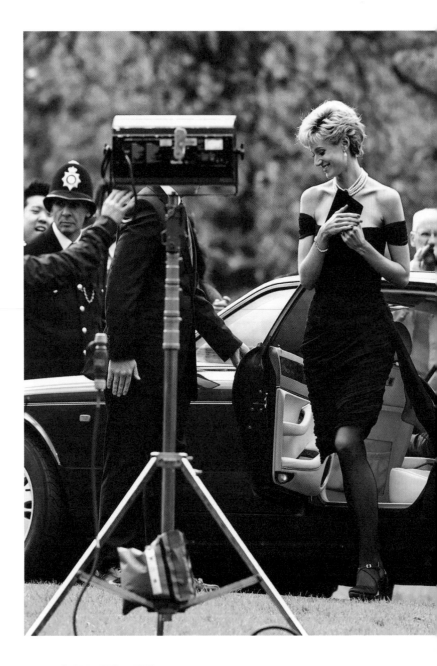

Elizabeth Debicki recreating the iconic revenge dress moment for season five of *The Crown*.

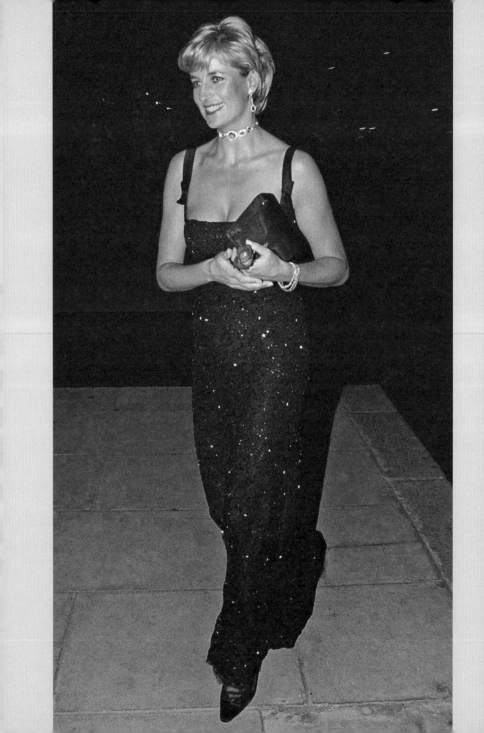

"*She really loved* the *world of* fashion, *and she liked the people in it. It was an* escape *for her.*"

STEPHEN JONES

Appearing fresh and confident on her 36th birthday, Diana sports a shimmering floor-length dress by Jacques Azagury, 1997.

Off-duty style

Diana's high-fashion styles charmed the world, but her off-duty looks played an important role in identifying her not as just a princess, with a wardrobe most other women could only dream of, but someone who had relatable personal taste. The former princess's weekend wardrobe offered her own take on the trends of the time. She paired denim with diamonds and oversized tees with designer handbags. Her laid-back looks were beloved by audiences at the time – and they're arguably even more loved now. Let's take a peek at some of the off-the-clock looks that Diana fans can't get enough of.

One of her most talked-about looks, which spoke to Diana's Sloane Ranger origins, was her "black sheep" jumper, which she wore with blue jeans to watch Charles play in a polo match in June 1981. The jumper was from Warm & Wonderful, an independent brand which started out from a stall in London's Covent Garden market.

The duo behind the label, Sally Muir and Joanna Osborne, spoke to the *New Yorker* about the outfit in 2020. They said they didn't know how Diana obtained the jumper, but that the rumour was that it was gifted to her by the mother of one of the page boys at her wedding.

The jumper would make a second appearance a few years after the couple's marriage, this time worn with a statement collar with black ribbon, high-waisted white jeans and oversized sunglasses.

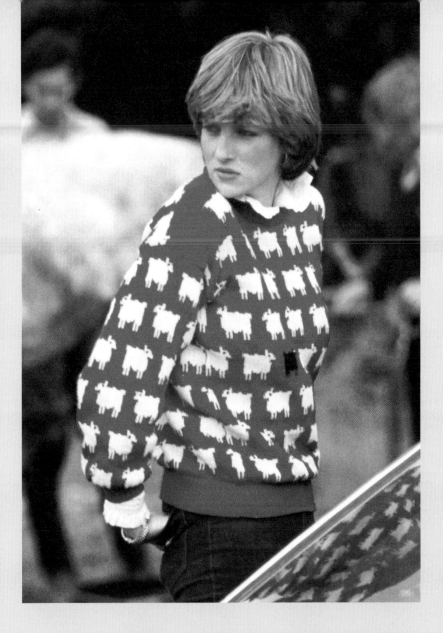

This design by Warm & Wonderful would go on to be one of Diana's
most coveted knitwear looks, seen here at a polo match in 1981.

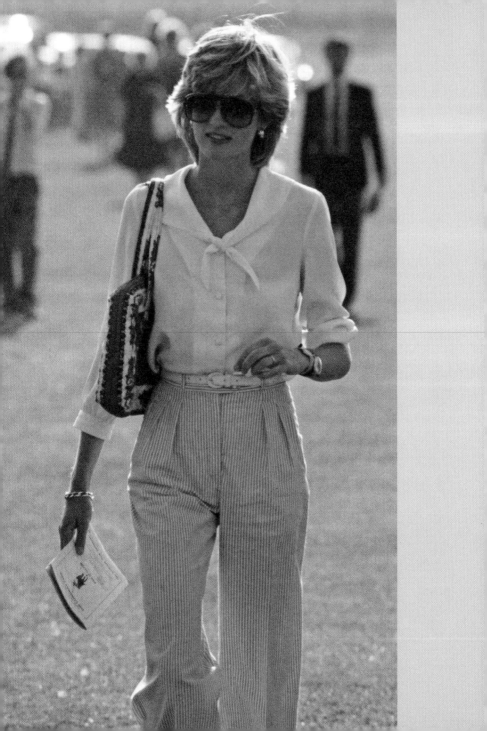

"*She dressed to communicate* **approachability** and *warmth* – *to encourage* *informality.*"

ELERI LYNN

An incredibly eighties look sported by Diana at
one of her outings to watch the polo in 1983.

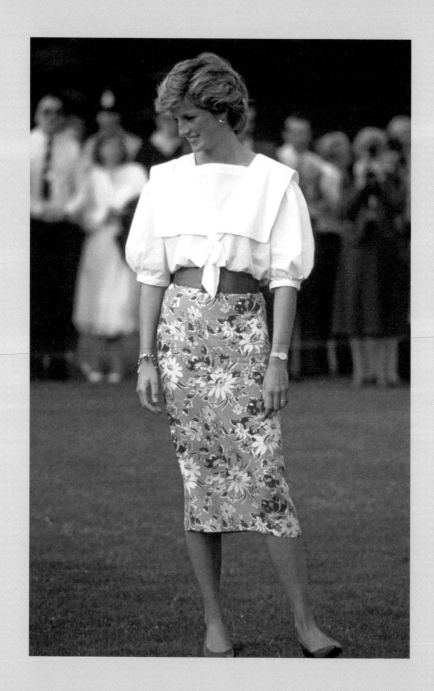

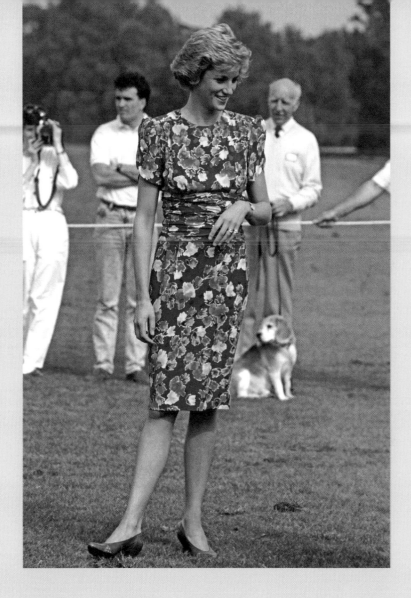

OPPOSITE Another polo match outfit, this time a floral skirt and sailor blouse, 1985.

ABOVE Diana embraces the eighties ruched-waist trend
in this floral Bellville Sassoon dress, 1988.

In a 2022 documentary, *Diana: A Life in Fashion*, fashion editor Penny Goldstone speculates on the significance of the jumper. "You can very much tell that there's been a shift between the two pictures. In the second image, she's standing straighter. She's kind of looking at the camera [...] I think the first time she wore it, [she] wasn't thinking anything about it." She went on, "A lot of people were saying it was a statement at the time because there were already a few arguments with Prince Charles. She was considered a bit of a rebel, she didn't want to follow all the rules in the family so it sort of symbolized her being the 'black sheep' of the Royal Family."

It takes some serious sartorial nous to throw together a look that not only continues to inspire the fashion world over three decades later, but also raises awareness of a good cause. Well, Diana had that talent. In 1988, the 27-year-old Diana stepped out to watch the polo at Guards Polo Club in Windsor. Recreated in season five of *The Crown*, the famous look consisted of one of her favourite navy baseball caps, rumoured to have been a gift from the Royal Canadian Mounted Police, an oversized blazer, white British Lung Foundation sweatshirt, blue jeans and slouchy leather boots. The British Lung Foundation was thrilled with the attention that resulted from the princess' moment of endorsement, but it wasn't just that the jumper was comfy: Diana had become a patron of the foundation two years earlier. The crew-neck style continues to be available for purchase on the foundation's website, which refers to it as the "Diana sweatshirt".

The Princess of Wales pairs a British Lung Foundation sweatshirt with jeans, boots and a baseball cap to visit the Guards Polo Club, 1988.

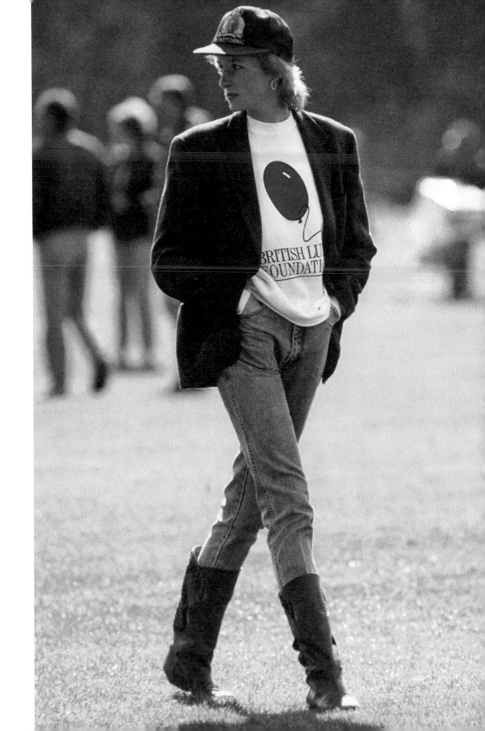

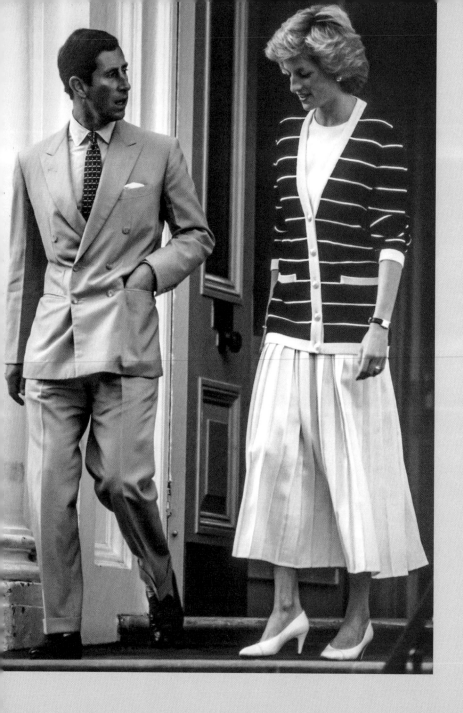

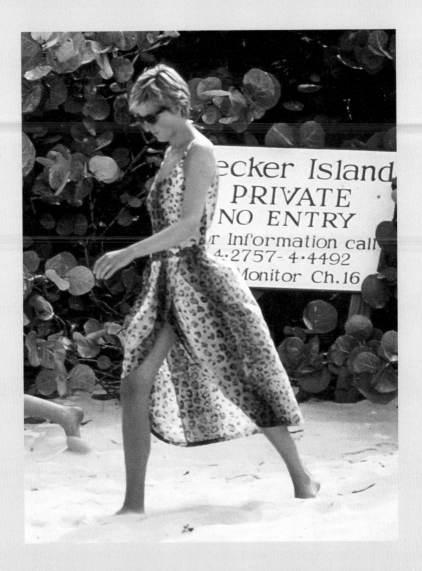

OPPOSITE Diana's 1989 school-run outfit embodies understated elegance, pairing a striped cardigan with a pleated midi skirt and simple pumps.

ABOVE Diana knew the power of a strong animal-inspired print when it came to holiday style, 1990.

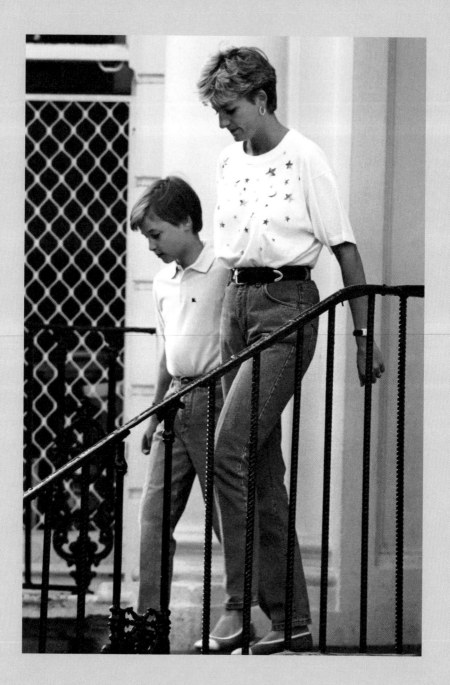

Many women will understand the importance of the perfect beach outfit for an Instagram-worthy holiday. Now imagine you're the most photographed woman in the world and your destination is Richard Branson's private island. Plus, there's a round-the-clock stakeout by photographers from some of the biggest newspapers and magazines in the world. By the looks of it, the pressure didn't get to her. Enjoying a royal family holiday, Diana made headlines with her leopard-print ensemble, which paired a classic one-piece swimming costume with a semi-sheer midi wrap skirt in the same pattern. She added sunglasses in one of her favourite shapes, the timeless Wayfarer. Jantzens, the Portland-based label behind the one-piece style, was reported to be one of Diana's favourites when it came to swimwear, as its designs suited a long torso, flattering her five-foot-ten frame. She'd go on to sport a similar style on the last holiday before her death, this time created by Israeli designer Gottex.

Double denim. A Canadian tuxedo. Whatever you call it, Princess Diana embraced the nineties' calling card while on a skiing holiday with her sons in Lech, Austria, in 1994. To many women, this look painted Diana as the perfect combination of fashion icon and approachable best friend – someone with whom you could see yourself going shopping, or sharing the *après-ski* lifestyle. The mid-wash look was punctuated with a crocodile-effect leather belt, a classic leather bomber jacket and white padded snow boots. Bonus points go to the young Prince William for those fleece-lined Moon Boots – the Y2K staple that Hailey Bieber, Iris Apatow and Dua Lipa have brought back into the limelight.

A young Prince William and Diana step out in denim, 1992.

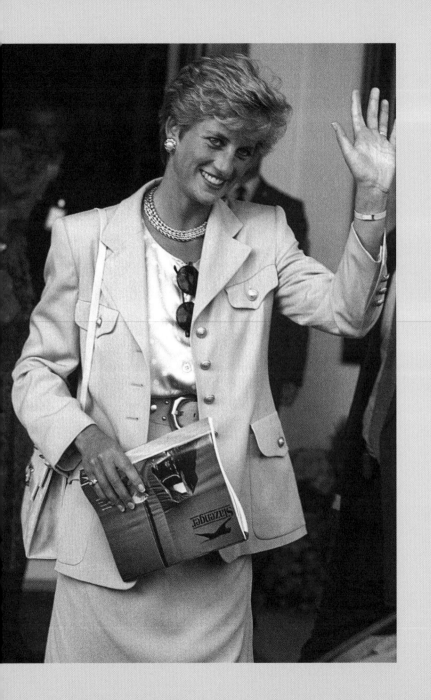

"*She was a superstar, she was royal, but she was also very approachable.*"

TIM GRAHAM

Gold-tone details make this Wimbledon look come to life, 1993.

In the summer of 1997, Diana took a trip to Bosnia with the Landmine Survivors Network. The 36-year-old philanthropist knew this wasn't an occasion to be sporting flashy styles or making big statements with her outfits. To keep the focus on the cause, her looks would need to be pared back. She opted for a pair of light-wash, high-waisted jeans with a tapered leg (we'd identify them as Mom jeans, but they weren't called that at the time) and a classic white shirt. Ironically, for many observers, the outfits Diana wore on this trip would go on to rank among her top fashion moments, giving her an air of effortless sophistication. The jeans and shirt were accessorized with a tan leather belt, Diana's trademark driving shoes, by elegant UK label Tod's, and understated gold jewellery. Diana's minimalist late-nineties style proved that the former princess could do no wrong when it came to casual dressing.

Diana beams in a casual varsity-style jacket while on an outing to the Alton Towers theme park with Harry and William in 1994.

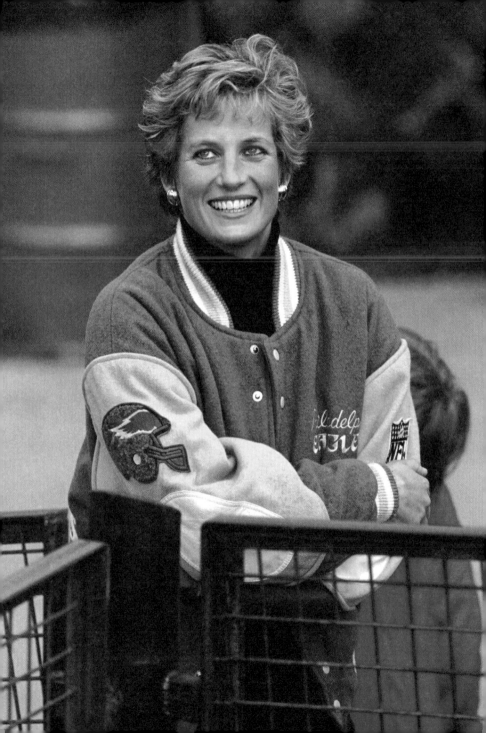

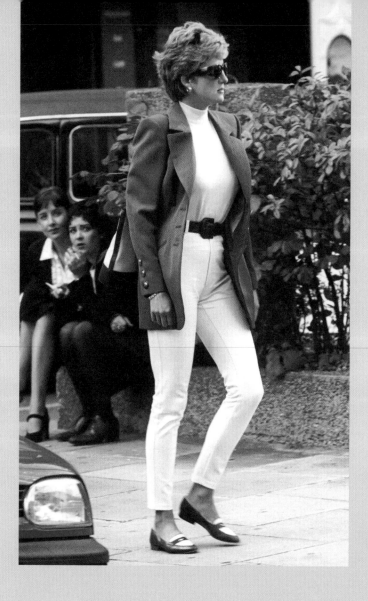

ABOVE Nothing beats a jeans and blazer combo, as proven by
this snap of Diana shopping in Knightsbridge, 1994.

OPPOSITE Diana was known to love her Gucci bamboo-handle
bag, spotted here after a trip to the gym in 1996.

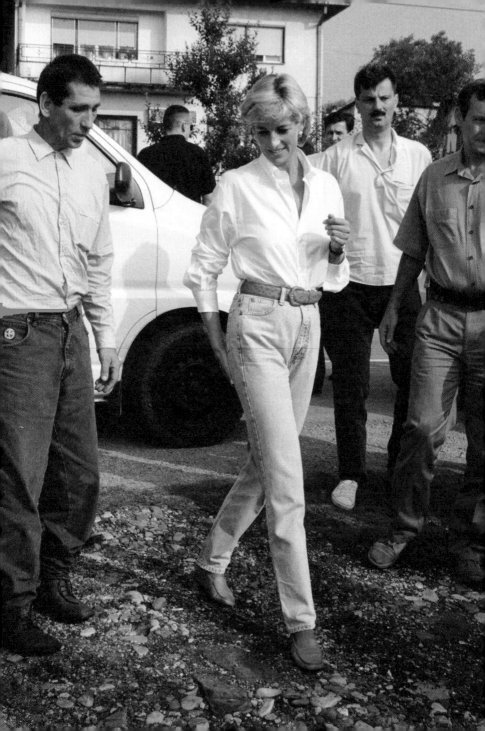

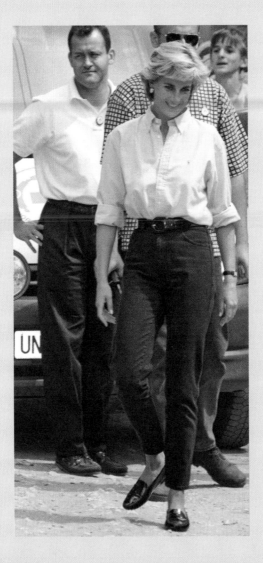

OPPOSITE On her final humanitarian trip, Diana wore light-wash jeans, a plain white shirt and her Tod's loafers, 1997.

ABOVE Diana's wardrobe for Bosnia was understated as per the fashion for casual looks of the time.

Sport

Long before names like Gymshark and Lululemon offered the world their deluxe high-waisted leggings, made using high-tech materials with names like Luxtreme®, and boasting advanced sweat-wicking technologies that sound like they're from outer space, the world of athleisure was very different. Your options were basically cotton, nylon and Lycra® – and Diana wore them all, with a sense of style that has echoed down the decades since. In 2022, pop culture commentator Kristen Meinzer told *Newsweek*, "[Diana] was kind of the 'Princess of Athleisure' before athleisure was even called athleisure." Diana's gym outfits, oversized sweatshirts and cycling shorts, worn with dad trainers and tube socks, have heavily influenced the looks that TikTok and Instagram have obsessed over in recent years – and it's easy to see why. It's impossible not to fall in love with Diana's nonchalant style a little bit more with every look.

OPPOSITE It doesn't get more nineties than a colourful ski onesie. Diana chose a one-piece by Austrian label Kitex for a ski holiday in 1993.

OVERLEAF Diana and Sarah Ferguson prove they got the memo when it came to skiwear choice, posing here for a photo during a ski holiday in 1983.

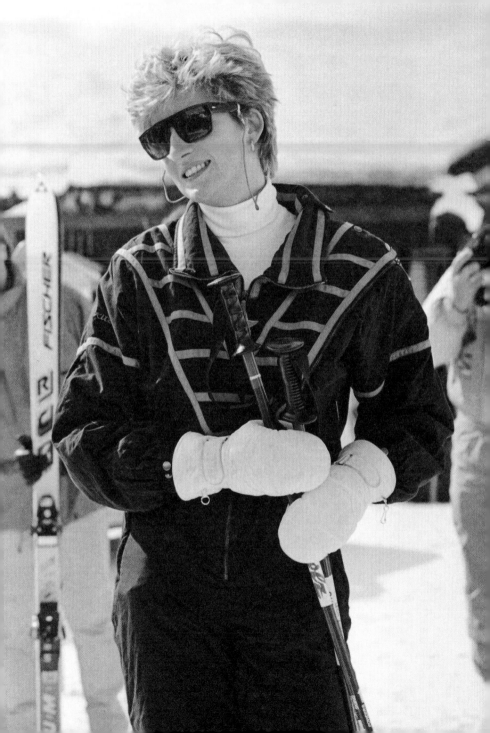

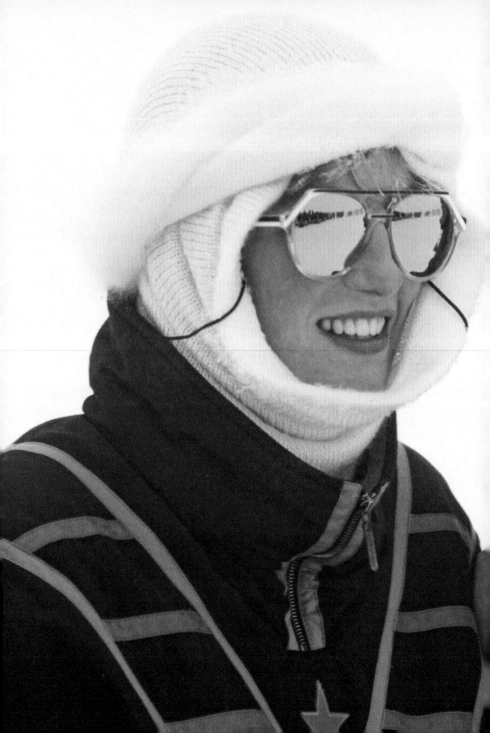

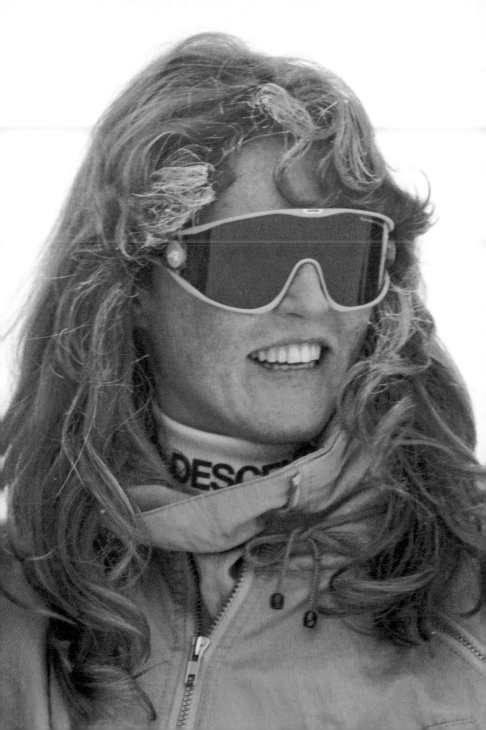

On a 1987 trip, Diana wore one of the most eighties outfits of all time, joining some royal companions to hit the slopes at the Klosters ski resort in Switzerland. Just one of many bold snowsuits that the princess would select over the years, this one-piece features a belted waist with green and hot pink trim and a star planted in the middle of Diana's chest. In 2022, this design from Austrian label Kitex can be found on a vintage clothing site priced at a staggering £3,150. The slope-ready look is completed with mirrored aviator sunglasses and an ivory snood that screams cosy. Honourable mention is due to Fergie's wraparound sunglasses and larger-than-life hairdo.

Diana spent much of the mid- to late nineties training at one of her favourite health clubs, the Chelsea Harbour Club. It was, in some ways, an unlikely setting for the looks that decades later would become some of her most celebrated styles. We can spot her trademark oversized cotton sweatshirt and bright cycling shorts combo in the picture overleaf from 1995. Diana also wears a pair of Nike Air Max Structure trainers with snowy white Reebok sports socks. This type of look was popularized by the step aerobics trend that swept through the fitness world from the late eighties until the late nineties. Diana's navy sweatshirt was a gift from her friend Richard Branson, the founder of the Virgin brand.

Diana embraces the nineties obsession with oversized sweatshirts and cycling shorts as she leaves the Chelsea Harbour Club in 1994.

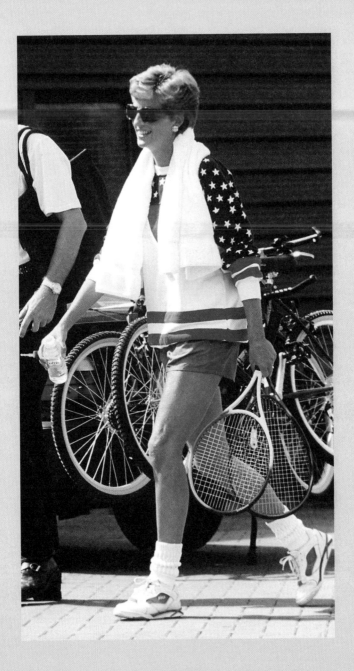

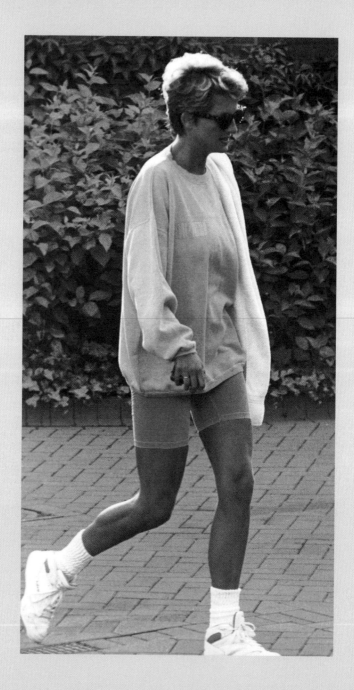

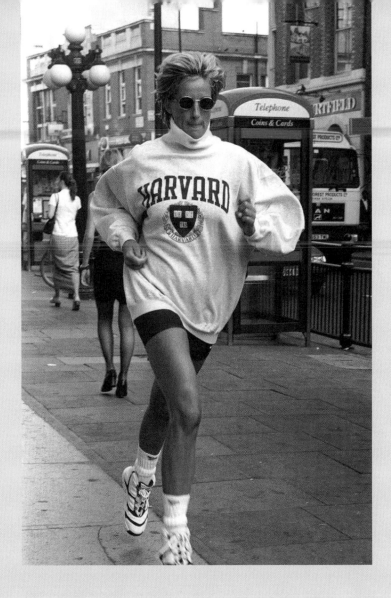

OPPOSITE The "People's Princess" wears a pale blue sweatshirt,
pink shorts and tortoise-shell sunglasses, 1994.

ABOVE Diana sprints through the streets of London wearing a mock-
neck Harvard sweatshirt, cycling shorts and chunky trainers, 1997.

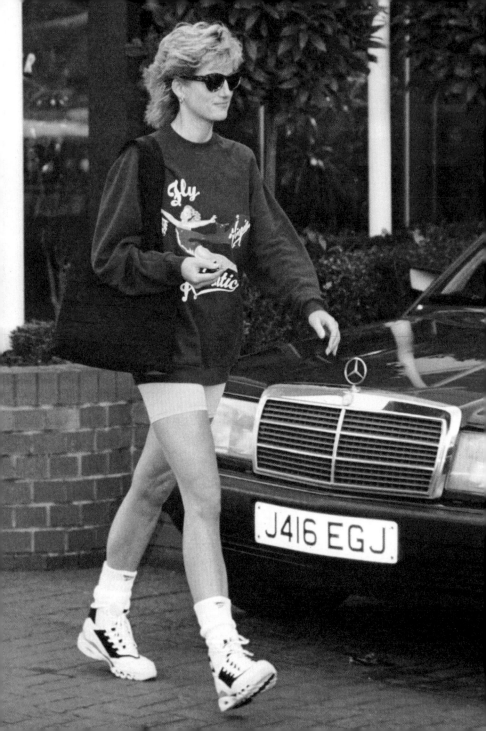

It would become a popular piece in Diana's wardrobe of gym wear. It was reported that she wore it frequently as a way to deter paparazzi: if she dressed in the same way every day, their photos would be nearly identical and wouldn't be so in demand. Replicas of the style are still produced – and still sell out – to this day. The original sweatshirt was given to Diana's personal trainer, Jenni Rivett, in the year before Diana's death in 1997. It would go on to sell for about £48,000 at an auction in 2019.

Another TikTok and Instagram favourite is Diana's Northwestern sweatshirt, photographed after a gym session in 1996. What makes this such a good look? It's the addition of the bamboo-handled Gucci tote and tortoise-shell sunglasses. The mash-up of contrasting styles really shouldn't work – but it definitely does. The crisp white of the cycling shorts and the sweatshirt's bold font make the 35-year-old Diana's sun-kissed skin glow. The trainers are Reeboks, a nod to one of Diana's favourite sportswear brands. So, where'd the crew neck come from? Well, Diana had paid Northwestern University a visit in 1996. The academic institution is situated a short distance north of Chicago, Illinois. The purpose of the trip was to help raise awareness and funds to support the university's cancer research – a goal she achieved, raising $1.5 million (approximately £2.6 million today). Coincidentally, Meghan Markle would study theatre and international studies at Northwestern, graduating seven years after the princess' visit.

The Virgin Atlantic sweatshirt was one of Diana's favourites, worn here as she leaves her gym in Chelsea in 1995.

The Key

CHAPTER 3

Pieces

For those who are familiar with Diana's approach to fashion, a few key elements may come to mind on hearing her name. There are the accessories she managed to consistently incorporate into her outfits over nearly 20 years in the limelight and the styles that punctuated different eras of her fashion journey. Arguably, Diana even managed to claim a few colour palettes over the course of her sartorial reign. But as we know by now, it was almost never the case that Diana simply grabbed off the rack something she liked the look of – there's a story to be told about each signature piece.

Jewellery fit for a princess

The story of Diana's jewellery easily warrants a book of its own (and it has). Her love of precious pieces evolved in many ways over the years. Pretty pearls, Cartier watches and sapphires complemented many of her most popular looks, from dramatic gowns to jeans and T-shirts. The princess used jewels to ensure that her elegance was always intact. Her choices continue to inspire fine jewellers and high-street designers alike to this day.

A 19-year-old Diana is photographed outside her Earl's Court flat, wearing her trademark pearls and knitwear, 1980.

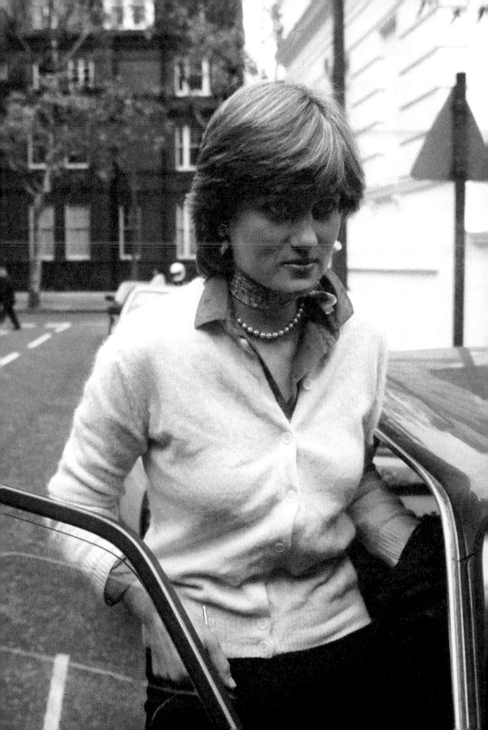

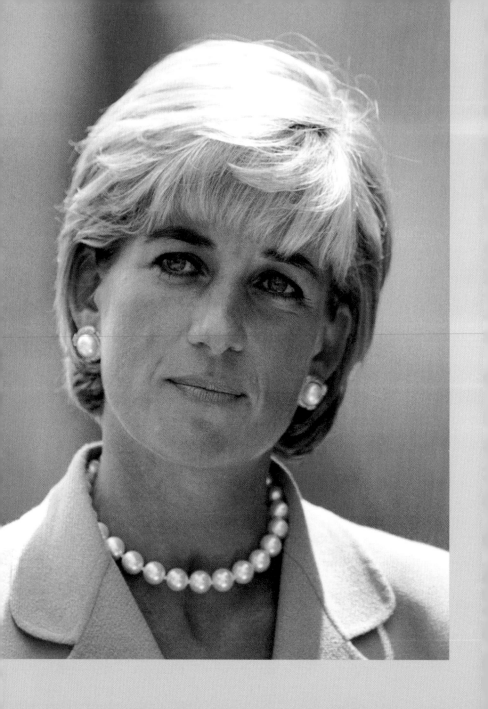

The power of pearls

In Diana's rollercoaster of a life, there were few constants, but pearls were always close to hand. In some of the earliest paparazzi photos of Diana, captured outside her flat in Earl's Court when she was dating Prince Charles, she can be seen wearing a classic pearl necklace. In the months before her untimely death, she was spotted in Washington, DC, wearing a pearl necklace at an American Red Cross event and a similar necklace to attend the funeral of her friend, fashion designer Gianni Versace.

It's rumoured that fashion phenomenon Coco Chanel once said of pearl necklaces, "Why wear one string when you can wear two?" It seems Diana encountered this notion and decided to take it a few steps further, sporting as many as seven rows of pearls at a time.

Some of Diana's favourite earrings featured pearls, notably the pearl and diamond drop earrings she was given on her wedding day by the Spencer family jeweller, Collingwood. Eagle-eyed fans will know that she wore the same pair both on her wedding day, with her pink "going away" outfit, and with the revenge dress. Make of that what you will.

Princess Diana wears a pearl necklace and earrings on a visit to the American Red Cross in Washington, DC, 1997.

"*I think Diana was probably a bit of a magpie – there's a real core identity that comes through her jewellery, because she did a lot of it herself. She enjoyed it.*"

AMY ROBERTS

The Princess of Wales proves she isn't one to shy away from statement pieces with this pairing of jumbo pearls and larger-than-life sunglasses, 1989.

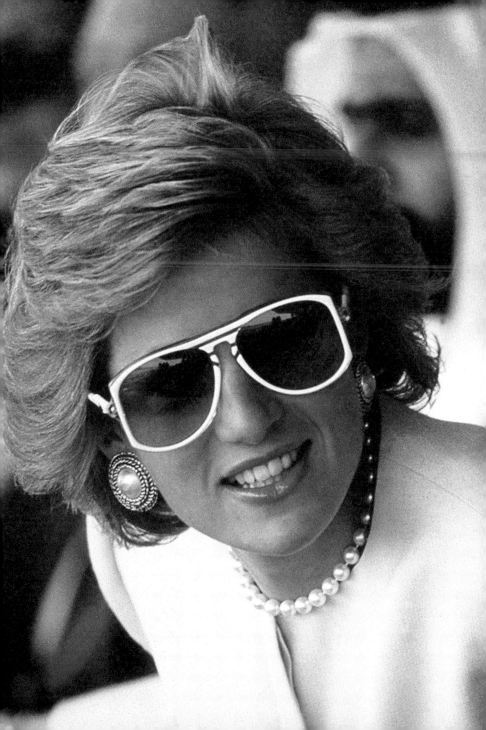

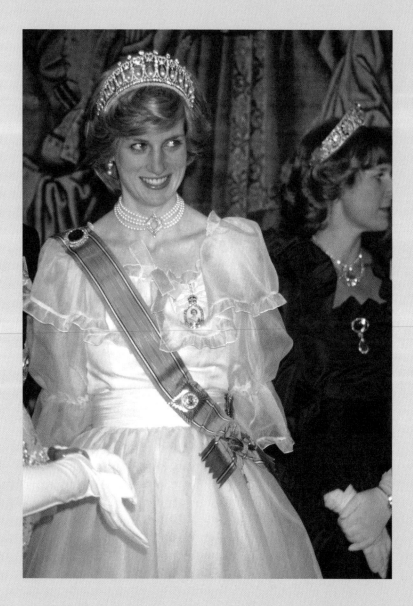

One of Diana's favourite and most versatile pieces came in the form of a
sapphire brooch, seen here at a banquet at Hampton Court Palace in 1982.

Sapphire: the royal stone

A wedding gift from her grandmother-in-law, The Queen Mother, Diana's sapphire brooch remained a constant feature of her attire throughout her many reinventions. Fashion historian Suzy Menkes explains, "The Queen Mother's wedding present to Diana was a duck egg of a sapphire, surrounded by a double row of diamonds and mounted as a brooch." Diana wore the attention-grabbing item pinned to the lace trim of her oh-so-eighties Bellville Sassoon dress when she attended a Downing Street banquet in 1981. She later wore the brooch at Hampton Court Palace for a state banquet in honour of Beatrix, Queen of the Netherlands, attaching the huge blue jewel to the vibrant tangerine sash of the Order of the Crown.

Ever the rebel, Diana did not keep this dramatic jewel as a brooch for long. She had it reworked as the centrepiece of an on-trend, seven-strand pearl choker, which she wore to concerts, the Met Gala and even to The White House, where she hit the headlines after being photographed dancing with John Travolta. In 1994, the necklace was the finishing touch to her infamous "revenge dress", perhaps worn as a final snook cocked at the family who had abandoned her. The historic piece hasn't been seen in public since 1994 and it's presumed it was inherited by her sons. Having been photographed in The Queen Mother's sapphire earrings and Diana's engagement ring, perhaps Kate will eventually appear wearing the sapphire. Valued today at over £100 million, it is one of the most expensive jewels in the royal collection.

The Cartier Tank

Another piece that accompanied Diana from her late teens to her late thirties was the Cartier Tank watch. Defined by its slim style and square face, the watch came to market in 1919, but the French jeweller wouldn't see success with the model until the 1970s, when celebrities like Andy Warhol and Jackie Onassis began to wear it. During their marriage, Diana often wore a gold edition of the watch that Charles had given her on her 20th birthday, but after their split she appears to have pushed this one to the back of the cupboard, switching for the Cartier Tank Louis, with an alligator strap, which her father had given her. Current fans of the style include Michelle Obama, Angelina Jolie and Meghan Markle.

Diana smiles at photographers on a 1995 trip to Argentina, wearing her Cartier Tank watch and clutching a Dior bag.

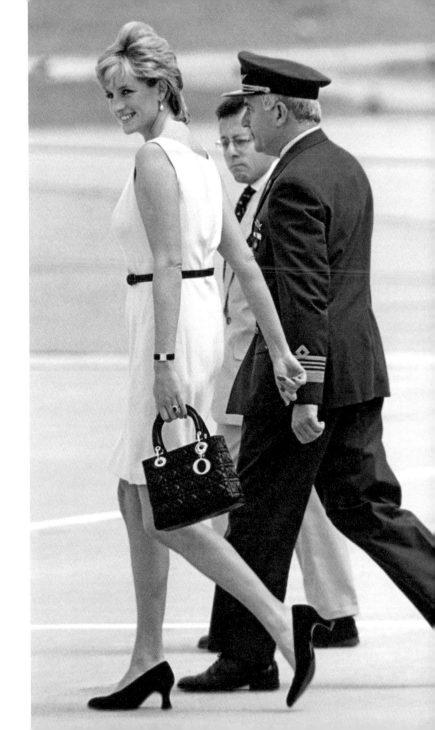

Athleisure sweatshirts

Graphic sweats were one of the key fashion pieces of the eighties and nineties. As the younger generation rejected wool jumpers and poplin shirts, the cotton crew neck became a canvas for brands and institutions to play with, making ordinary people and A-listers alike into walking billboards. Luckily for the wearers, the printed sweatshirt was also seriously comfortable.

Diana's approach to the graphic sweatshirt was almost always tactical. Many would look at the sweatshirt as a straightforward item of comfortable clothing, but Diana understood its power. The princess used her sweatshirts as a tool to deter the press, as with the blue Virgin Atlantic sweater she grabbed for nearly every gym session throughout the mid-nineties, or as a way of promoting the causes closest to her heart – as with the white British Lung Foundation top she wore in the early nineties.

Though she was said to have failed her O levels (the equivalent of GCSEs) twice, Diana's sweatshirt game gave the impression that she was an alumna of some of the most elite universities in America. Her cowl-neck Harvard sweatshirt is one of the most recreated numbers, with brands such as H&M and countless Etsy sellers mimicking the look.

"It's an awesome talent, fashion-wise, to take things that look pretty normal and make them look almost unhinged. On most women, it's what we call personal style. On Diana, it reads like a psychologist's notepad," says fashion journalist Rachel Tashjian.

"*I believe as her body became* fit, strong *and* healthy, she felt empowered *and ready to face those bad times head-on.*"

JENNI RIVETT

"*Famed* for her pastel cycling shorts, oversized collegiate jumpers and Reebok Classics, Diana's downtime wardrobe embodied the '*People's Princess*' moniker given to her by the media."

ALICE NEWBOLD, *VOGUE*

Dressing down with juxtaposition in the form of the Gucci bag. London, 1996.

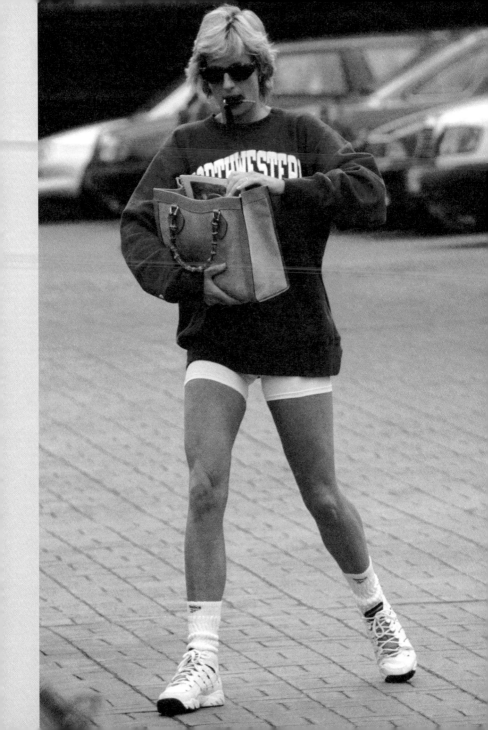

A love of loafers

Much has been said about women's relationship with shoes. Most quotations on this topic are the type of thing you'd find on a cushion at TK Maxx. But we can agree that shoes are a pretty key way to tell the world who you are. You could probably tell Diana's life story just by talking about her footwear choices over the years, but there was one particular style that would see her through – the loafer. She displayed a marked preference for the shoe throughout her life, from her days of awkwardly trotting through West London as photographers worked to catch a glimpse of the 19-year-old who was rumoured to be dating Prince Charles, right up until her final humanitarian trip to Bosnia in 1997. Diana's love for the loafer would outlast her marriage. The Tod's Gommino driving shoe is usually cited as one of Diana's favourite styles: the former princess was captured wearing the suede shoes in a range of colourways, including classic tan, soft sky blue and light khaki. Other notable fans of the style include Chiara Ferragni and Suki Waterhouse.

These Tod's loafers would become one of Diana's signature styles. She wears them in tan on a 1997 trip to Angola.

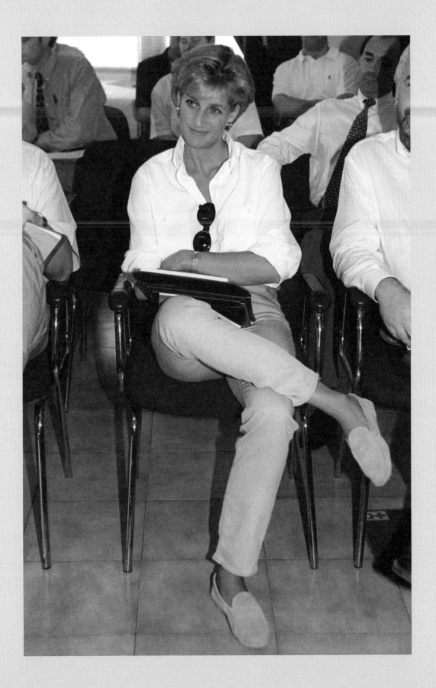

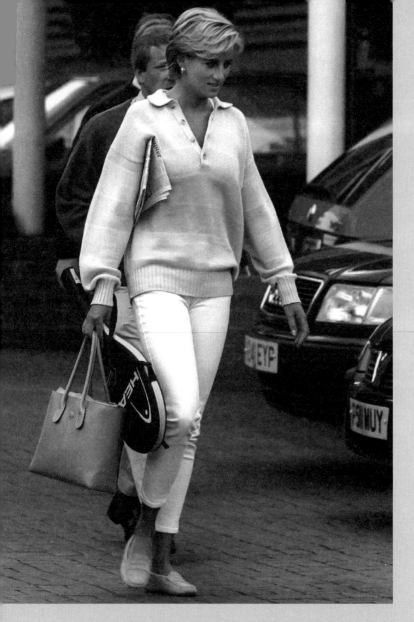

In case you missed the loafers, Diana demonstrates her love for Tod's once again with this choice of handbag, 1997. The Italian company named the "Di" model after the Princess of Wales.

Diana's denim

From the mid-eighties, Diana began to wear a wider range of denim styles, from light-wash dungarees to classic Mom jeans. Her preference for denim was not only a fashion statement but also a token of her accessible status as the "People's Princess".

Daniel Miller, a UK anthropologist who has studied the significance of the denim favourite, describes the power of jeans as follows: "Jeans convey the idea of being a simple, unaffected, everyday kind of person, friendly and inoffensive [...] Jeans cause no bother, physically or socially."

With this in mind, we might speculate that Diana's affinity for denim went beyond a style preference and was in fact a signifier of her desire to be "normal" and connect with her peers as she navigated the complex world of royalty, fame, motherhood and her own independence.

Diana's denim looks are often the most beloved of her outfits for her present-day admirers, a generation who have become fans of the late princess on TikTok and Instagram. And what pair of jeans is more timeless than Levi's 501s? Diana wore the denim classic with an oversized tee on school runs or a simple white blouse on philanthropic missions abroad.

"They're simple, they're not complicated," says Lynn Downey, archivist and historian at Levi Strauss & Co., about the original Levi's 501 jean. "It's just denim, thread and rivets." And yes, Diana was bitten by the double-denim bug. She's seen on the following page with a young William and Harry on a ski holiday to Austria in 1993.

"Don't call me an icon. I'm just a mother trying to help."

PRINCESS DIANA

Diana pairs high-waisted indigo jeans with a matching shirt, leather jacket and white snow boots while on a ski trip to Austria, 1993.

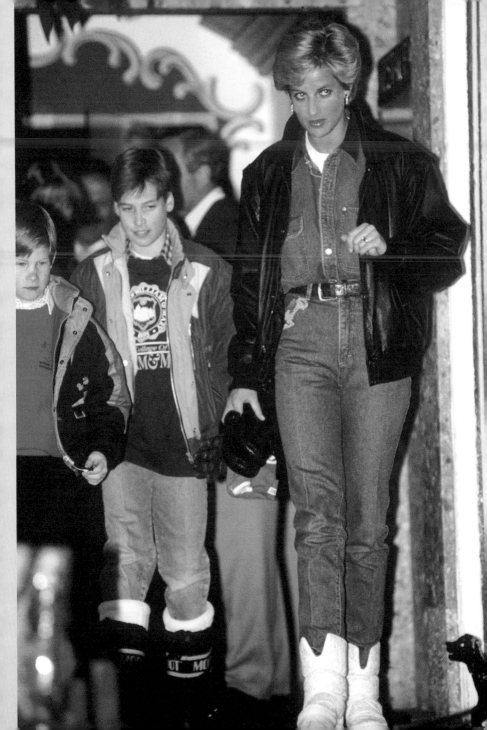

The tank dress

The shift dress, the tank dress – whatever you want to call it, it was one of Diana's favourite styles throughout the nineties. It made such an impression that *Vogue* referred to it as Diana's "secret weapon". And one unlikely name stood out from the rest – Versace. Though designers like Jacques Azagury and Catherine Walker dressed Diana in the pared-back style, the Versace tank dresses were the ones that really captivated the press.

Defined by its low-cut, rounded neckline and simple straps, the dress style was worn by the late princess in one of the most extraordinary photo shoots of her lifetime. The November 1997 cover of *Harper's Bazaar*, published two months after her untimely death, shows Diana in an embellished, ice-blue Versace dress (overleaf). The shot was captured a full six years before her death but wasn't featured on the cover until afterwards.

There are two other Versace tank dresses that sit among Diana's best looks: a black, figure-hugging model that featured two button straps, and a white number with silver charms on the straps that she wore in 1995 at the Children of Bosnia charity concert in Modena, Italy. "The sample Versace shift dresses were probably her most successful looks to date," Diana's former stylist Anna Harvey told *Vogue*.

Diana attends a private event at Christie's in a pale blue number by Catherine Walker, 1997.

"The sample *Versace* shift dresses and evening columns that Catherine Walker was doing for her were probably her most successful looks to date."

ANNA HARVEY

The silk Versace gown that Diana wore on the cover of *Harper's Bazaar* is displayed at a 2017 exhibit entitled *Diana: Her Fashion Story*, hosted by Kensington Palace.

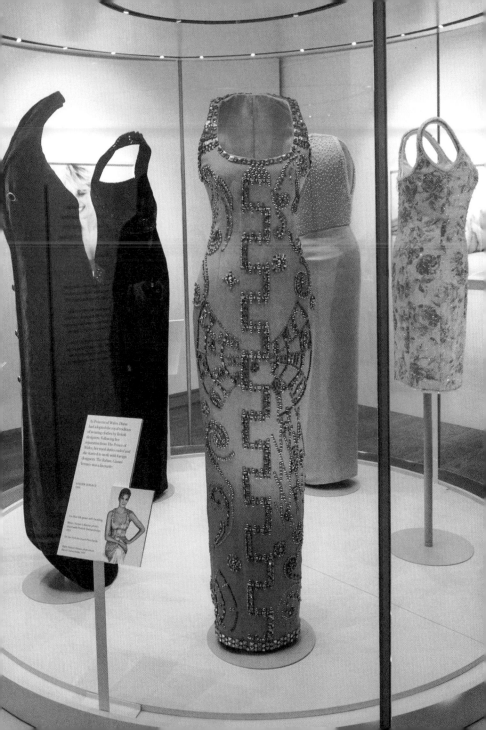

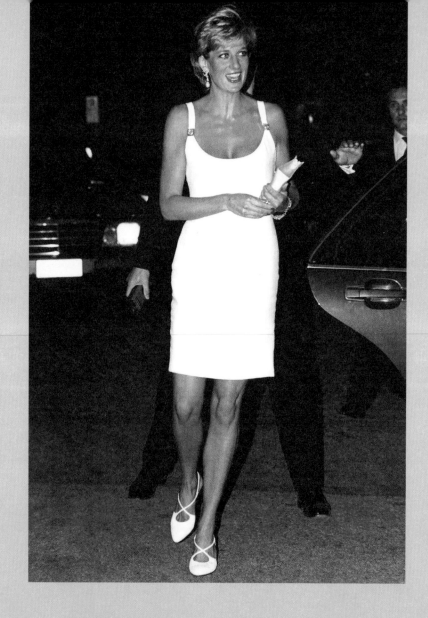

ABOVE Diana wears Versace to an Italian fundraiser event, 1995.

OPPOSITE This Versace tank dress was one of Diana's favourites,
worn here to the *Apollo 13* premiere in 1995.

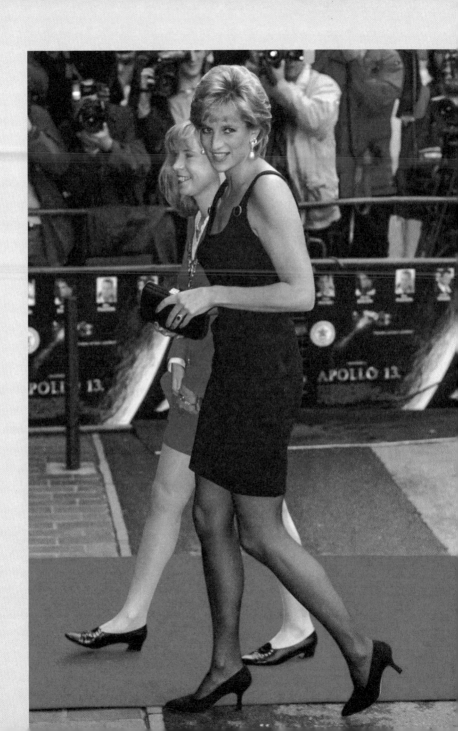

Pink power

There's never been a more divisive colour than pink. Which made it the perfect hue for a revolutionary figure like Diana. For the better half of the twentieth century, the colour has, for many, signified femininity. In the 1940s, American parents were encouraged to use pink to indicate their baby's sex – and the trend spread from there. It's a complicated colour: some see it as the shade of frivolity or a hue best reserved for the "dumb blonde" trope, but others believe it to be a powerful colour that should be embraced and reclaimed.

In *Pink: The History of a Punk, Pretty and Powerful Color* by Valerie Steele, the fashion historian notes, "Jayna Zweiman and Krista Suh chose the colour pink [for the knitted hats worn by women on feminist protests, beginning in 2016], they said, because it was 'a very female colour representing caring, compassion and love – all qualities that have been derided as weak but are actually STRONG.'"

As Diana navigated royal life, the colour pink communicated her non-threatening, almost angelic character. In the nineties, she reclaimed the hue as a power move. Pink came to represent the unapologetic softness of her character. She described this best herself in her notorious 1995 *Panorama* interview. In response to journalist Martin Bashir's question about why she thought she might not have been accepted by many of the royal family, she stated, "Because I do things differently, because I don't go by a rule book, because I lead from the heart, not the head, and albeit that's got me into trouble in my work, I understand that. But someone's got to go out there and love people and show it."

A hot pink style complements Diana's cheerful demeanour
on an outing in Manchester, 1993.

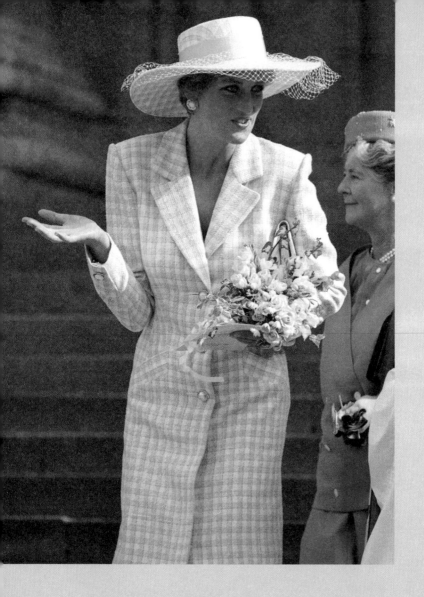

ABOVE Lady Di wears a pink and white coat dress designed by Catherine Walker
and a Philip Somerville hat with a veil to a service at St Paul's Cathedral, 1990.

OPPOSITE Diana pays homage to Jackie O with a tailored two-piece,
designed for her by Gianni Versace, on a 1995 trip to Argentina.

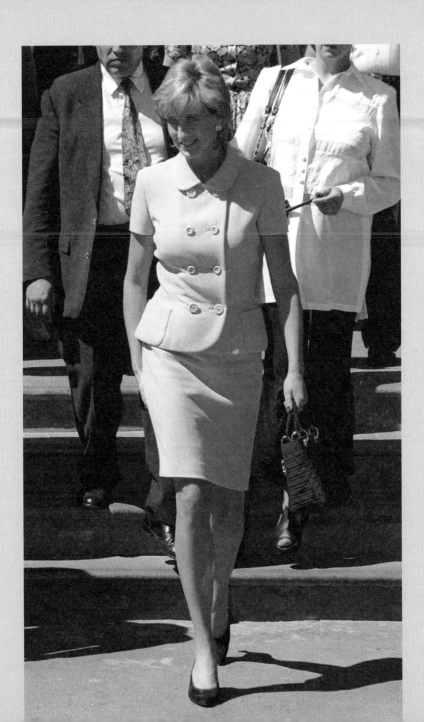

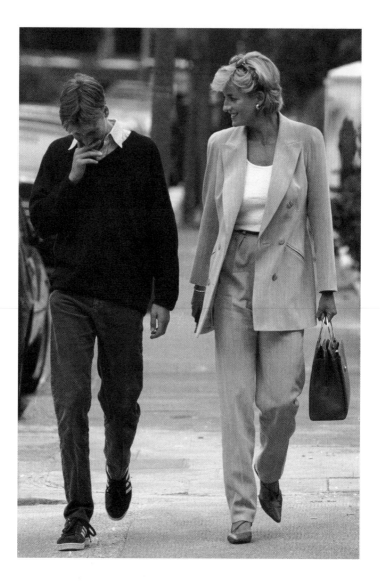

Say hello to nineties minimalism at its finest with this straight-cut suiting style in a muted sand colourway, paired with a scoop-neck top, tortoise-shell sunglasses and tan accessories, London 1997.

The blazer

"The item of clothing that makes us feel powerful is the one that makes us feel confident and self-assured, that magically makes us look our best in all kinds of circumstances."
Valerie Steele, fashion historian

We all have pieces in our wardrobes that make us feel powerful. For Diana, the item imbued with this strange magic was probably the blazer. Early on, they appeared in red velvet, then as an oversized addition to nearly every outfit the princess wore. Later, they became her go-to piece to channel a nineties minimalist vibe. The blazer was Diana's preferred pick throughout most of her adult life. It's a garment that demands respect, and which gestured to the world that Diana was not here to mess about – even when it was paired with acid-wash jeans or a midi skirt.

Alice Newbold, the executive fashion news and features editor at *Vogue.co.uk*, wrote in January 2022, "In Diana's hands, the blazer became more than just a signifier of 'business'. She veered from her so-called 'Sloane Ranger' preppy style and paired her jackets with long-line pleated skirts and pumps; tracksuits and cowboy boots. She was seminal in propelling the blazer forward as an all-rounder, not just something to take to work."

It's no wonder that Diana's blazer-based looks are some of her most popular outfits among fashion lovers on TikTok and Instagram. They're just so *her*.

"Blazers were a mainstay of Princess Diana's wardrobe, segueing from the **power-shoulder** styles of the eighties to **chic**, continental cuts in the nineties, which were worn with simple chinos or jeans."

THE *TELEGRAPH*

OPPOSITE A red-cheeked Diana dons a red blazer over a black roll-neck during her courtship with Prince Charles, 1980.

OVERLEAF Diana poses in an oversized blazer style for a photo with Harry, William, Charles and Eton headmaster Dr Andrew Gailey on William's first day, 1995.

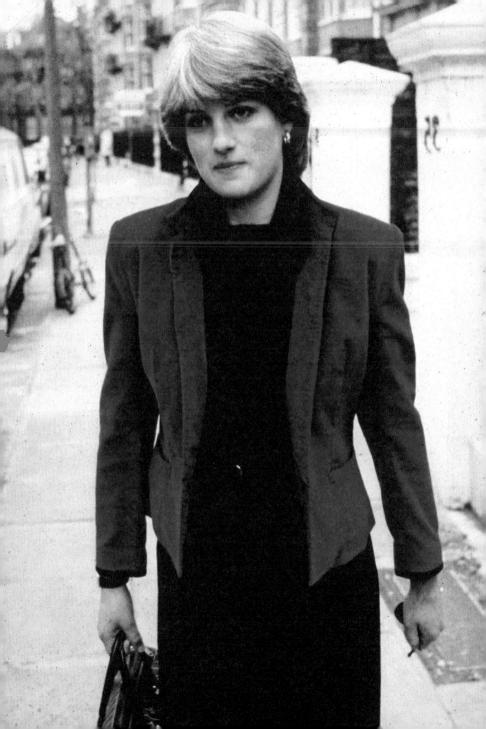

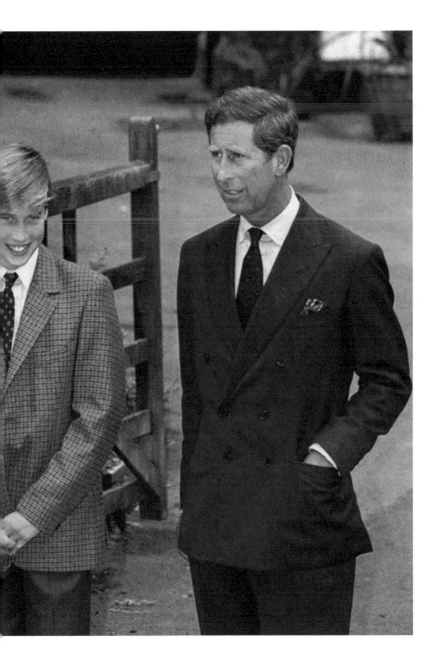

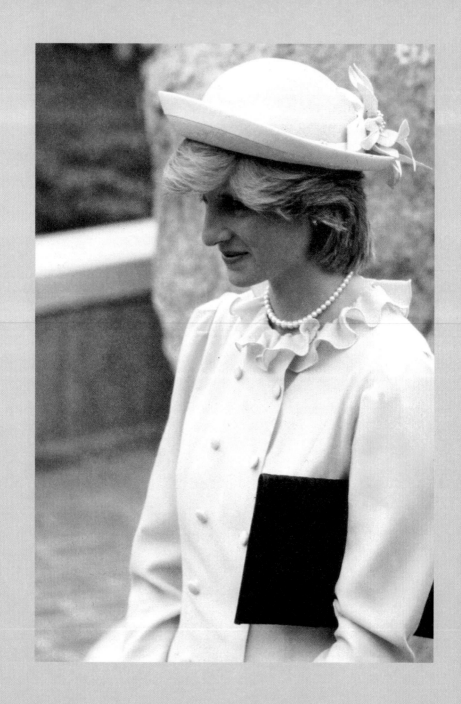

Collars, collars and more collars

Diana's love of big, bold collars, demonstrated throughout the eighties and early nineties, is impossible to miss. Likely a key influence on the continuing modern-day obsession with the collar (see Ganni and Miu Miu, for starters), Diana's collar collection exhibited some seriously impressive breadth. In her Sloane Ranger years, the Edwardian-inspired pie-crust collar was her go-to style, often worn beneath a knitted cardigan or woolly jumper. She also sported dresses with delicate lacey collars, a look that defined Diana's daintier era.

Pussy-bow blouses featured in some of the princess' strongest eighties looks. Statement collars were just one of the many style elements that showed Diana's dedication to experimenting with the details. A floor-grazing velvet dress in a deep navy blue would be gorgeous on its own – but add a lace collar, and the look becomes a total hit. A teal polka-dot day dress would make the papers by itself, but with the addition of a statement collar, the outfit becomes even more special. Diana demonstrated to the world the power of a big, bold collar – and we're still showing our appreciation today.

Diana dons a feminine frill collar on a
royal visit to Canada in 1983.

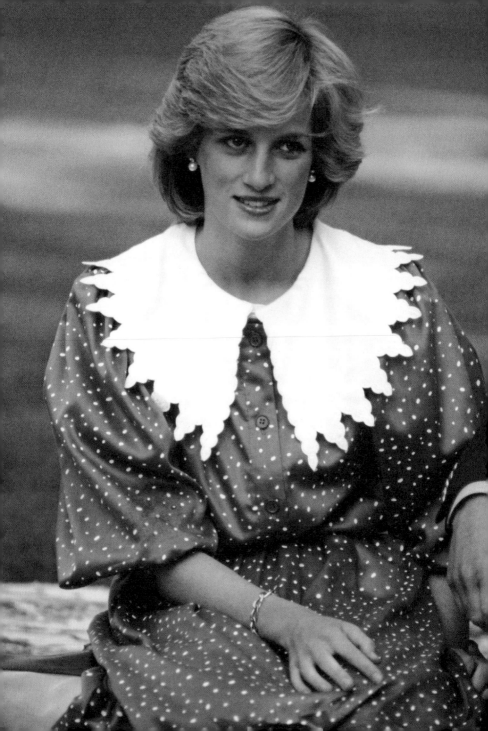

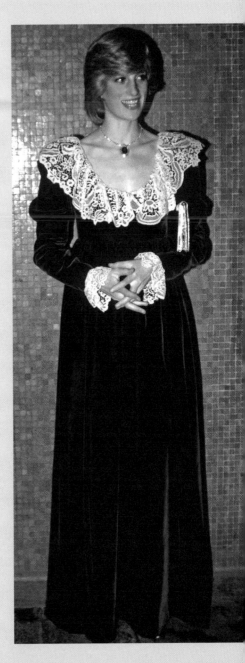

OPPOSITE The eighties were all about
going bold – and Diana got the memo.
Here she's pictured in a polka-dot
dress with a bold collar worn on a visit
to Auckland, New Zealand, 1983.

RIGHT Diana attends a dinner at the National
Film Institute wearing a velvet dress in
deep navy with lace cuffs and collar, 1981.

Dior bag

Diana's "cleavage clutches" were named for their role in helping Diana maintain some modesty following a wardrobe near miss during her first official appearance with her then boyfriend, Prince Charles, in 1981. But if we take them out of the equation, Diana's handbag collection was pretty understated. She often opted for the same select styles over the years. Her preference for quality over quantity is evidenced by her two designer favourites – enter the Lady Dior bag and the Gucci Diana bag.

Diana's love of Dior went beyond her favourite handbag. Her glamorous look for the 1996 Met Gala featured a slip dress and silk robe designed by John Galliano during his Dior era. But it would be the quilted Lady Dior bag that would go down in fashion history as one of Diana's most memorable accessories. The bag first appeared on Diana's arm in Paris in 1995, when she attended a retrospective of the artist Paul Cézanne. At the time, the design hadn't yet been released by the French fashion house and internally, it was simply referred to as the "chouchou" bag. The story goes that the bag was a gift to Diana from the First Lady of France at the time, Bernadette Chirac. The exhibition would be the first of many occasions on which Diana would reach for the bag, inspiring Dior to name it the "Lady Dior" in 1996. The design has been reinterpreted in countless styles since, notably for the Dior Lady Art project, which gave artists working across a range of disciplines an opportunity to add their own unique twist to the accessory.

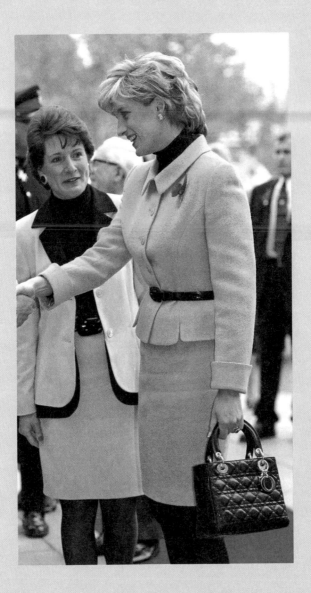

Versace dressed Diana in a bright orange ensemble for a visit to Liverpool, styled here with the iconic Dior handbag. The fashion house continues to sell the bag decades later as a tribute to the late princess.

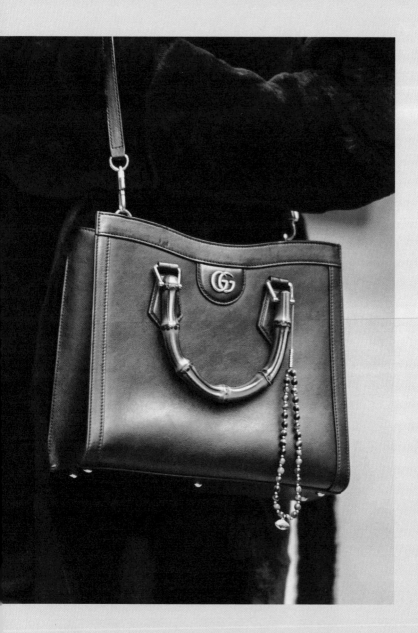

The Gucci Diana bag remains a favourite with handbag lovers across the globe.

Gucci bag

For Diana's off-duty looks, Gucci's bamboo-handled bag would become a trusted go-to staple. In fact, the design had been around long before Diana was even born. The story goes that Gucci created the bag in 1947 in response to a scarcity of leather in Italy following the Second World War – hence the use of bamboo. Known at that time as the 0633 bag, the model would propel the Italian label to new heights. The unique bamboo feature became a calling card for Gucci's dedication to premium craftsmanship (each handle is lacquered and carefully manipulated into shape by hand).

The 0633 has since been renamed the Gucci Diana bag and adapted for a new generation with a rerelease in 2021. It's a key piece in the "Gucci Beloved" collection, which reimagines Gucci's most iconic bags (the favourite bag of Jackie O, one of Diana's style heroes, was also updated and reissued as one of the series). The 2021 version of the Diana bag features a neon strap and has been spotted on the arms of stars such as Elle Fanning and Jodie Turner-Smith.

Gucci's aesthetic of fusing high fashion with streetwear owes a lot to Diana. Photographs of the princess digging through her 0633 bag, dressed in her signature off-duty look of sweatshirt and shorts, have been shared tens of thousands of times across the social-media platforms Instagram, Pinterest and TikTok. Gucci has cannily capitalized on this free advertising – and on the popularity of all things Diana in this online realm – by rereleasing the 0633 under its new name. It's an It bag for Gen Z, the streetwear-loving generation who haven't known life without social media – the only barrier to its fashion ascent might be its £2,999 starting price.

Her

CHAPTER 4

Legacy

A new era of appreciation

In the eighties and nineties, Diana fans would have needed to head to the newsstand or switch on the television set to catch a glimpse of the latest statement outfit. These days, Diana's fan base exists in a very different world. Without the distractions of vicious rumours about her love life or her personal struggles, a new generation can admire Diana for her wardrobe and her habit of making a powerful statement via the length of a hemline or the pattern of a jumper.

Her perceived attitude toward the institution of the royal family arguably resonates more with the younger generation today than it did at the time. As our society becomes increasingly self-aware and willing to take a stand against tradition in the name of a fairer world, Diana's talent for rebelling against outdated practices (often through her outfit choices) makes her a welcome role model. This reason for the resurgence of her fame is demonstrated when we consider the most-viewed clips of her on YouTube – her public snooze session during a visit to the Victoria and Albert Museum in 1981 reaching 19 million views by 2023 and her jaw-dropping *Panorama* interview with Martin Bashir, raking in nearly 7.5 million views. These clips record two key moments where Diana, whether on purpose or not, appeared to display a devil-may-care attitude towards "the Firm". Evidently, we love her for it.

Stephanie Yeboah is one of the many online influencers known to recreate Diana's iconic looks, pictured here at the BFI in 2022.

When it comes to Instagram, the number of accounts dedicated to Diana and her style seems to be infinite, and many garner hundreds of thousands of followers. Comments such as "Princess Diana is a different level of woman", "indisputable queen Diana", "How do we dress like Diana – what do we need?" and "a true lady and humanitarian" show how she is remembered by those who were present to witness her life and those who have come to know her after her death.

Diana's reach could be summed up with a checklist of a few of the people emulating her looks on Instagram: a small, representative sample would take in Australian TV personality Liv Phyland, Stephanie Yeboah, an author and body image activist from South London, and American actress and filmmaker Tommy Dorfman.

TikTok has also played a key role in creating a new wave of Diana fans. Countless videos set out to recreate the late princess' most legendary looks, and clue watchers in on where to shop for the necessary components.

Using the handle @simplesmurf on TikTok, Kaden Luna has become one of the most popular Diana fans on the platform. He explained to *Vogue* in 2021 that his obsession with the "People's Princess" began when he saw stars such as Harry Styles and Hailey Bieber reference her in their looks.

Actress Tommy Dorfman showed her respects for Princess Di with her 2021 Halloween ensemble which showed her mimicking the iconic "Sleeping Beauty" look by Bellville Sassoon, posted to her Instagram account and garnering over 150,000 likes.

"The *Diana aesthetic* has endured the ages. Today, brands continue to take cues from *key looks* in the Princess of Wales' wardrobe ..."

THE *INDEPENDENT*

The release of the fourth season of *The Crown* further inspired the Texan influencer. "Me and my #princessdiana sweater collection vs the world", one caption reads. By 2022, his Diana-related content had been watched by hundreds of thousands of people, clearly demonstrating a widespread interest in Diana's fashion legacy.

The *Daily Mail* reported on this surge of enthusiasm for Diana among users of the social media platform, dubbing her "the TikTok princess" in one article from 2021. The piece highlighted a key factor in Diana's popularity with a quote from Gen Z TikToker Jade Honey.

"There's something incredible about a princess wearing the coolest street style, especially back then. A lot of her casual outfits exuded that 'off-duty model' vibe that's so popular with celebrities now. I couldn't imagine the Duchess of Cambridge doing the same thing," the Isle of Wight-based fashion lover told the publication.

American influencer Morgan Riddle went viral in July 2022 when she was spotted in the stands at Wimbledon supporting her pro tennis player boyfriend Taylor Fritz. Her head-turning look was influenced by one of Diana's casual outfits from 1995, as Riddle explained in her TikTok. In just six months, the post was viewed over a million times.

Another post that paid homage to Diana was made in March 2021 by TikTok user Shay Rose (or @crescentshay). It depicted the DIY fashion queen taking an eleven-dollar dress found at her local Goodwill (an American thrifting institution) and transforming it into the iconic "revenge dress". 6.5 million people around the world liked the post.

"*I understand that change is frightening for people, especially if there's nothing*

to go to. It's best to stay where you are. I understand that."

PRINCESS DIANA

The head-to-toe look

Eighties make-up and hairstyling was truly something else. Aside from the occasional celeb experimenting on the red carpet, larger-than-life curls and blazing neon make-up represent an approach to beauty that twenty-first-century fashionistas are happy to leave safely in the past. However, while Diana's clothes were typical of her time, her hair and make-up often took a pared-back approach. Dutch TikToker Rose Van Rijn (or @70srose on the platform), proved the timelessness of Diana's beauty regime in May 2021 when she posted a tutorial explaining how to achieve Diana's flouncy hairdo on the social media platform. At the time of writing, the video has been viewed a staggering 20.5 million times. Van Rijn told *Allure*, "Diana is long gone but I hope to carry on her legacy, even if it's just a bit by wearing her hairstyle again and showing it to other people on the internet."

More evidence that Diana's style legacy extends beyond her wardrobe appears in a 2017 video posted by celebrity make-up artist Lisa Eldridge. She remarks that she's been bombarded with requests for her to do a "Princess Diana look". She welcomes a member of Diana's make-up team, Mary Greenwell, to demonstrate how the princess liked her make-up done to an audience of over two million viewers. (Greenwell has now worked with Meghan Markle – interesting to imagine the conversations they must have had.)

Celebrity make-up artist Mary Greenwell is credited for working with both the late Princess Diana and Meghan Markle to help them shine in the spotlight. Here she attends the Fenty Beauty x Harvey Nichols launch in 2017.

(They just get) It girls

I won't claim that Diana was "the original influencer" (though many do), but the popularity of all things "People's Princess" on social media is testament to her long-standing legacy across fashion history and pop culture. And like her, some of Diana's keenest A-list fans inherited their fame through family connections. Celebrity models Hailey Bieber and Kendall Jenner have both publicly demonstrated their interest in Diana's life and style through their attire and in interviews.

Two years after her editorial homage to Diana in *Vogue France*, Bieber told *Harper's Bazaar* in August 2022, "I was really inspired by the fact that she was the most-looked-at woman in the world at that time, of all time, and she did what she wanted with her style. She really expressed herself through her style despite being in the position she was in."

Three decades after the original look was photographed, Kendall Jenner has been spotted in a nearly identical outfit to Diana's ensemble that featured sweatpants tucked into cowboy boots, worn to take Prince William and Prince Harry to school in 1989. Jenner also named Diana as one of her style icons in a July 2019 piece in *Vogue*, noting that Diana's high-waisted, slim-fitting jeans are one of her favourite denim looks.

Hayley Bieber wears an undeniably Diana-inspired outfit while out in Los Angeles in October 2019.

Model Emily Ratajkowski, a close friend of both Bieber and Jenner, has also caught Diana fever, as demonstrated by her enduring love of an oversized blazer and images of her in a pinstripe dress that reminds us a lot of one of Diana's 1996 looks.

"I'm trying to go eighties and have been thinking about Princess Diana's street and ready-to-wear moments like a blazer and a bike short and a big sneaker," she told *Us Weekly* in 2019.

Rihanna has also publicly voiced her appreciation for the Princess of Wales. "You know who is the best who ever did it? Princess Diana. She was like – she killed it. Every look was right. She was gangsta with her clothes. She had these crazy hats. She got oversize jackets. I loved everything she wore!" the pop megastar told *Glamour* in 2013 (it should be noted that Rihanna expressed this sentiment long before the Diana mania that has swept social media in the last few years).

The Barbadian star's appreciation for Diana would only grow over the years. In 2017, she told *W Magazine*, "Whether her choice of this knockdown dress was conscious or not, I am touched by the idea that even Princess Diana could suffer like any ordinary woman. This Diana Bad B*tch moment blew me away."

Kendall Jenner tucks her blue jeans into chunky boots with a boxy blazer while in NYC in November 2019.

ABOVE Diana fan Emily Ratajkowski steps out in New York City wearing
a pinstripe blazer dress similar to one of Diana's favourites, 2018.

OPPOSITE Rihanna wears a Chrome Hearts slip dress, Los Angeles, 2015.

Her sartorial references to the princess include a T-shirt by NYC label Chapel decorated with an image of Diana's face, which she wore in 2016, and a black slip dress and robe from Chrome Hearts, worn in 2015, which looked remarkably similar to Diana's Gucci look at the 1996 Met Gala.

Former boy band frontman and fashion icon of the moment Harry Styles has also mimicked Diana's looks. At the 2020 BRIT Awards, he was seen in a Gucci suit paired with two of Diana's style staples – an oversized collar and a pearl necklace. The stylist behind the look, Harry Lambert, told *Vogue* that Princess Diana was a key source of inspiration. In November 2019, Harry was spotted in a sweater vest from Lanvin that fashion commentators were quick to compare to Diana's 1980s "black sheep" jumper.

The power of Diana's style has undergone exploration by the actors who've played the "People's Princess" in numerous films and TV programmes released over the years. Emma Corrin, the star that depicted Diana in the fourth season of *The Crown*, reworked the "revenge dress" when they attended the premiere of *My Policemen* in September 2022. They starred in the film alongside another of Diana's celebrity fans, Harry Styles. Designed by Italian label Miu Miu, Corrin's captivating, gauzy black number featured an off-the-shoulder cut and dramatically trailing sleeves. The look was finished with diamond drop earrings from Cartier and stilettos nearly identical to those Diana wore on that summer's evening in 1996.

Emma Corrin wears a revenge-dress-inspired look
by Miu Miu to a film premiere in 2022.

The star of *Spencer*, a controversial 2021 film based on Diana's life, Kristen Stewart has also been photographed mimicking Diana's looks. The American actress was spotted in November 2021 pairing cycling shorts with a cropped Chanel jacket. A few months later, while attending the Oscars with fiancée Dylan Meyer, Stewart again wore shorts, taking a more tailored approach this time around. Chanel provided an oversized blazer for the outfit, a playful take on traditional menswear. Subverting menswear looks was a favourite pastime for Diana.

ꟼHer story: retold

In 2019, Netflix debuted *The Crown*, a series that would present a "semi-fictionalized" version of the history of the royal family. The suspense mounted as fans of the programme (over one million of whom tuned in for the first season) waited to hear when Diana would be portrayed – and by whom. Finally, in April 2019, in anticipation of the programme's fourth season, it was announced that Emma Corrin would be taking on the responsibility of playing Diana: the season spanned the years 1979 to 1990.

Despite the enormous pressure that Corrin experienced while preparing for the role, they told the *Sunday Post* that they had enjoyed the wardrobe and styling: "I loved all the looks. There were three different wigs and I loved them all. I liked the first one a lot because I love younger Diana and her sense of fun."

OVERLEAF Elizabeth Debicki portrays Diana in the fifth season of *The Crown*. Here they look pensive in a bejewelled halterneck dress, 2022.

"She was a young woman very much *living her life* and growing up in the public eye. She was a concerned *mother*, a *fashionista*, there were so many aspects to her that fuelled a media frenzy, a curiosity about her."

ARIANNE CHERNOCK

The costume team on *The Crown*, led by Amy Roberts and Sidonie Roberts, took the task of dressing Corrin as Diana extremely seriously. They even consulted the original designers of Diana's 1981 wedding dress to ensure that the replica was exactly right.

It's also been reported that the team consulted the designer behind the original "revenge dress", Christina Stambolian, before crafting a version for Elizabeth Debicki to wear in season five. The Greek designer was happy to give her approval. "It was important to remember to be very respectful of the original designer," Sidonie Roberts told *Byrdie* in an October 2022 interview. "The revenge dress is such a tricky thing to make – to work out how you even have the opening on a dress like that, how she's going to get into it, you've got a crusted body just draped by delicate chiffon."

It wasn't just the design of the dress that would go on to become so significant – but the term "revenge dress" itself. The world witnessed Diana's moment of rebuke and recovery as comparable to a phoenix rising from the ashes: a fierce power play. Many women appear to have taken note. The most fabulous revenge-dress styles of the years to follow would include Mariah Carey's dramatic 1997 two-piece following the diva's break up with Tommy Mottola (a far cry from her previous wardrobe of sixties-inspired swing dresses) and Bella Hadid's totally transparent Alexander Wang look at the 2017 Met Gala following her split with The Weeknd (Kendall Jenner showed solidarity in a similar see-through style, hers designed by La Perla).

A young Mariah Carey made headlines with her revenge look at the 1997 MTV Video Awards.

Bella Hadid stunned in Alexander Wang with support from best
friend Kendall Jenner in La Perla at the 2017 Met Gala.

Diana on the runway

Numerous designers and fashion houses have noted Diana as one of their key influences season after season. But in 2017 – the 20th anniversary of her untimely death – the whole industry was poised to reflect on Diana's legacy, particularly her enduring impact on the world of fashion. What better way to pay your respects to the "People's Princess" than to dedicate an entire runway collection to her? From Danish indie womenswear label Saks Potts to one of the world's most adored streetwear labels, Off-White, designers raced to pay homage.

Virgil Abloh, the mastermind behind Off-White, declared on Instagram that Diana was a key influence on the label's SS18 collection, three days before the 20th anniversary of her death. The label posted an array of snapshots of Diana, with labels like "mom", "countryside girl", "jogging" and "charity" pinned between the photos, demonstrating the many personas she represented throughout her lifetime. The designs took inspiration from prints, cuts and signature styles that had appeared in Diana's wardrobe and inspired comments such as this one from fashion writer Carrie Goldberg in *Harper's Bazaar*:

"Diana wore white for black tie, daytime and casual weekend activities, but for Off-White's finale, Virgil Abloh decked Naomi Campbell in an amazing ivory evening coat, paired with cycling shorts and a sexy lace-up, perspex-covered heel. This was Princess Di 2.0 at its finest, pairing her activewear with inspiration from her most stately looks and daring accessories."

One of the Diana-inspired looks from the Off-White SS12 RTW collection, featuring a two-piece baby blue skirt suit and stark white sport socks reminiscent of those worn by Lady Di in her gym-going days.

A few months after the collection was presented at Paris Fashion Week, the brand released two limited-edition T-shirts which paid tribute to Diana's wardrobe. The proceeds went towards the American Red Cross and the British Lung Foundation, one of Diana's favourite charitable organisations.

With fans including models Slick Woods and Bella Hadid, and French influencer Adenorah, Saks Potts could teach anyone a thing or two about It girl style. Launched in Copenhagen in 2013, the label has inspired young women across the globe with its rejection of the traditional Scandinavian monochrome aesthetic.

For the label's AW18 collection, designers Barbara Potts and Catherine Saks looked to Diana for inspiration. "[Princess Diana] dared to take chances and dress differently from what you would expect of a woman in her position," the duo told HarveyNichols.com (the present-day web presence of one of Diana's favourite London shopping spots). Potts and Saks also discussed their style hero with Coggles.com. "We would have loved to see Princess Diana wearing the collection we made for her, but we hope she would have liked it."

A few years later, Diana fans were treated to the rerelease of two of the best known pieces of knitwear from the princess' wardrobe – the "black sheep" jumper and a tongue-in-cheek sweater by British knitwear designers Giles & George, with "I'm a luxury" written across the chest and "few can afford" emblazoned on the reverse. New York City-based label Rowing Blazers teamed up with the jumpers' original designers for the new drop, milking its status as a favourite of celebrities like actor Timothée Chalamet and comedian Ziwe Fumudoh to attract the attention of the sartorially inclined across the globe. Comedian Pete Davidson was an unexpected yet fitting choice to model the label's SS21 collection, which included two more iterations of the "black sheep" jumper, in a sky-blue colourway and a zip-up fleece style.

Naomi Campbell wears a double-breasted blazer paired with cycling shorts branded with the Off-White logo for the SS18 collection at Paris Fashion Week.

Forever influential

Drag artist Bimini, whose fashion chops are widely admired by the industry, has been outspoken about taking Diana as their fashion muse. Key tributes have included an outfit worn to perform at Download Festival in 2022 and a Diana-inspired pink look worn for their appearance in the November 2021 documentary *Diana: Queen of Style*. But the RuPaul's *Drag Race UK* finalist's love of Diana goes far deeper, as attested to in an interview with *Kerrang* in July 2022:

"Princess Diana was punk because she went against the monarchy with what she did at the time. Like, listen, she was going to where people had AIDS, during the AIDS epidemic, and hugging someone. Humanizing them was the most punk thing ever – that's the punk attitude."

Fashion writer Justine Picardie articulated her eternal influence perfectly, stating in a 2021 documentary, "Every generation will return to Diana because every generation understands the fabric of life, the fabric of love and loss [...] What we are recognizing is something that reflects in ourselves: in our own joy, our own sorrows, our own grief, our own happiness, our own losses. That's there, in the fabric of her clothes."

Diana's influence continues to span across cultures and generations the world over. And much of this can be attributed to her wardrobe choices. Beyond the daring colourways and striking styles, there was often a message that lay beneath – and communicating through fashion is something that never goes out of style.

Bimini sports Diana's face on a ruched tee while performing at Download Festival in 2022.

Index

Credits

The publishers would like to thank the following sources for their kind permission to reproduce the pictures in this book:

Alamy: BRIAN HARRIS 20; Greg Balfour Evans 22; PA Images 41; Anwar Hussein 52; Francis Specker 55; REUTERS 78; Anwar Hussein 81, 92; PA Images 82; Trinity Mirror/Mirrorpix 127; Trinity Mirror/Mirrorpix 131; PA Images 137; PA Images 148; Trinity Mirror/Mirrorpix 178; Dom Slike 208-209

Getty Images: Tim Graham 9, 10, 14, 28, 35, 36, 39, 44-45, 47, 48, 49, 63, 87, 88, 99, 101, 108, 111, 113, 114, 117, 157, 161, 163, 166, 169, 171, 176-177, 181, 183; Bettman 17, Universal Images Group 18-19; Steve Back 25; Jacob Sutton 26-27; David Levenson 32; Anwar Hussein/WireImage 40; UK Press 56; Princess Diana Archive/Stringer 60, 67, 69, 73, 75, 95, 102, 112, 132-133, 143, 147, 180; Georges De Keerle 70, 72, 100; Central Press/Stringer 77; JUSTIN TALLIS 84-85; Keystone/Stringer 89; David Levenson 91; Pete de Souza 96-97; Julian Parker 118, 119, 120, 125, 126, 167; Tom Wargacki 122; Mirrorpix 128, 129, 170; Anwar Hussein 136, 138, 175; Antony Jones 158; Jack Taylor/Stringer 165; Edward Berthelot 184; Jeff Spicer 189; Mike Coppola 190; David M. Benett 197; BG002/Bauer-Griffin 198; Alessio Botticelli 201; Christopher Polk 203; GEOFF ROBINS 205; Kevin Mazur 211; J. Kempin 212; Karwai Tang 213; Francois Guillot/AFP 215, 216; Joseph Okpako/WireImage 218

Shutterstock: 31, 172; Brendan Beirne 15, 155; Tim Rooke 144; Times Newspapers 151

Splash News: 106-107

Every effort has been made to acknowledge correctly and contact the source and/or copyright holder of each picture and Welbeck Publishing apologises for an unintentional errors or omissions, which will be corrected in future editions of this book.